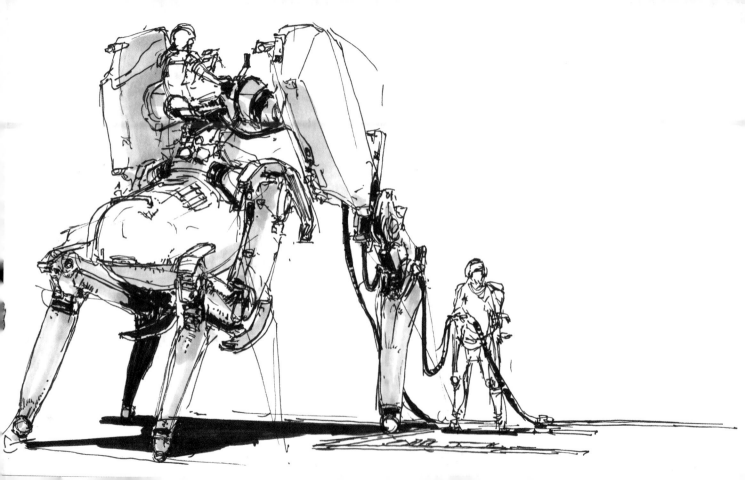

INKWORKS

Art Direction: Scott Robertson
Graphic Design: Christopher J. De La Rosa
Interview: Teena Apeles

10 9 8 7 6 5 4 3

Printed in China
First edition, December 2014
Hardcover ISBN: 978-1624650-15-4
Library of Congress Control Number: 2014951125

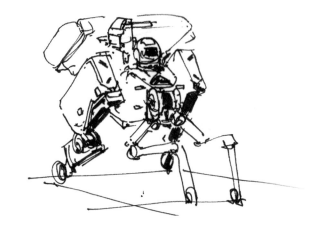

INKWORKS vol. 1

Design Sketches by DARREN QUACH

designstudio|PRESS

Introduction

In early 2013, I had a conversation with my friends, designers John Park and Khang Le, about our views on the importance of drawing and, more specifically, the importance of design sketching. We felt having this skill was an integral part of being a designer working in the entertainment industry. Design sketching can be a quick and gestural way to describe an idea.

What initially started as a discussion with friends and sketching, eventually led to *Inkworks*, this collection of mechanical design sketches done over a few months, which I now share with you. I have decided to keep a faithful reproduction of the original Cottonwood sketchbook layouts. Besides providing that initial spark of inspiration, the ideas in this book can serve as a springboard for further exploration or development. I hope you enjoy looking through these sketches as much as I enjoyed putting this collection together.

— *Darren Quach*

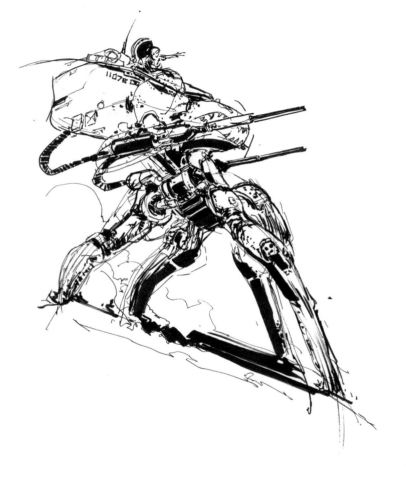

Video Tutorials

Throughout the book, you'll find INKWORKS along the side of the page like you see here. This means there is complementary video content that shows the process used to create the images on the page!

Scan the QR code below in order to navigate to the video page.

If you wish to view the videos without a mobile device, go to the following URL:

www.designstudiopress.com/inkworks-vol1-videos

Video Pages
5, 21, 31, 33, 68, 91

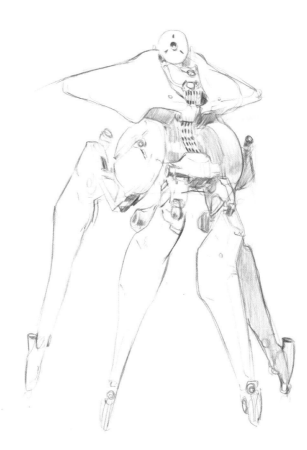

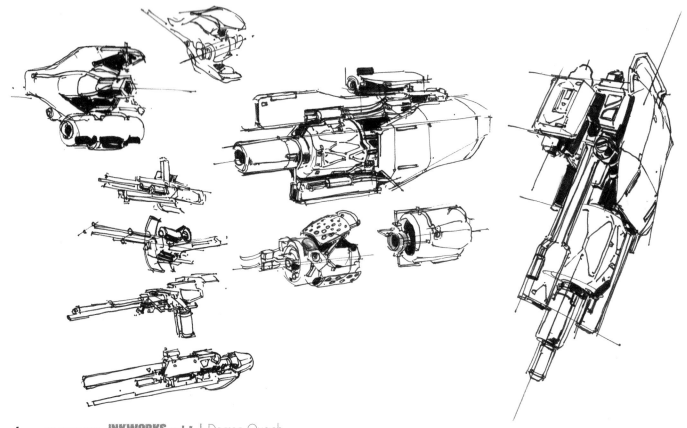

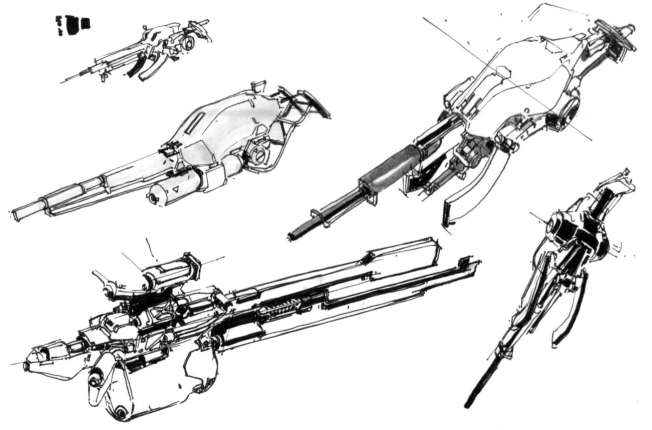

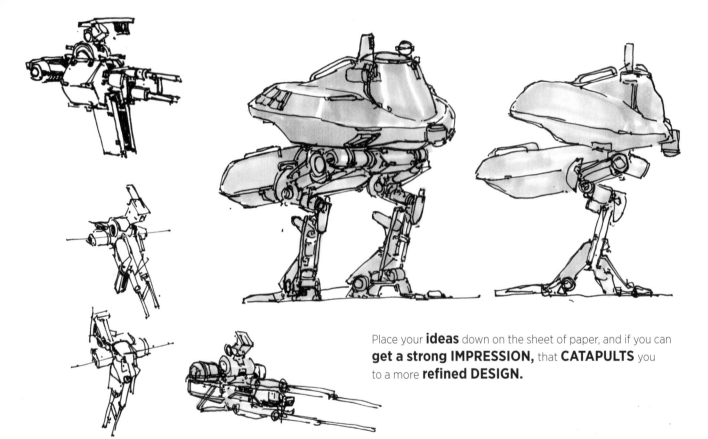

Place your **ideas** down on the sheet of paper, and if you can **get a strong IMPRESSION,** that **CATAPULTS** you to a more **refined DESIGN.**

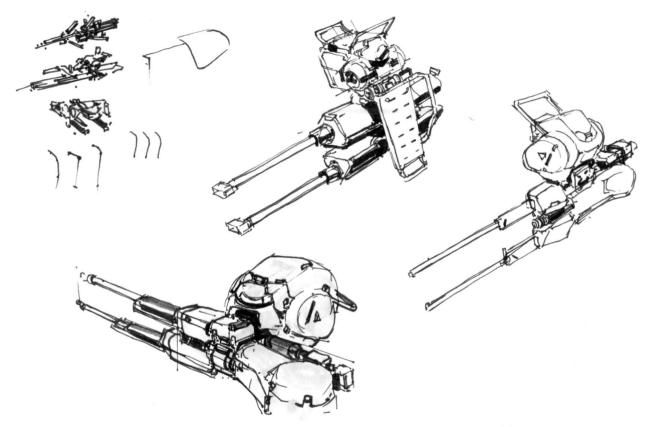

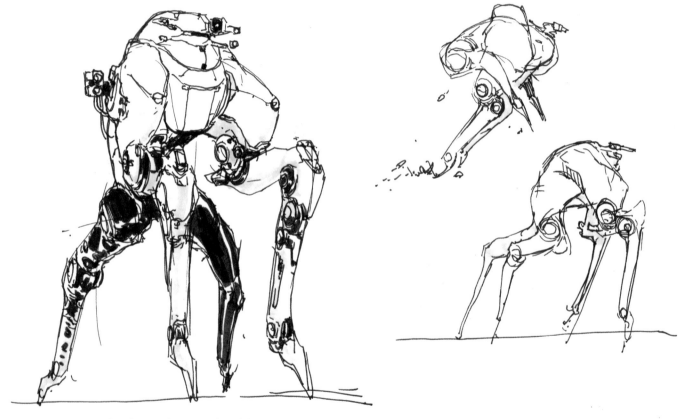

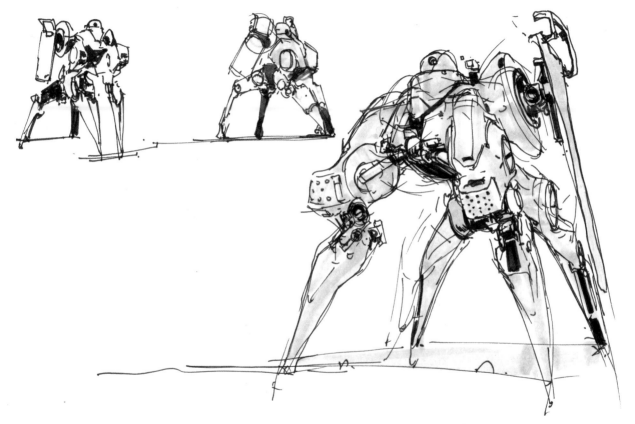

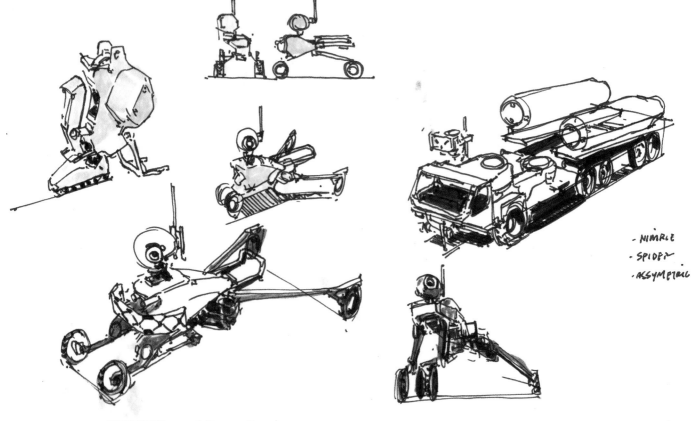

- NIMBLE
- SPIDER
- ASSYMETRIC

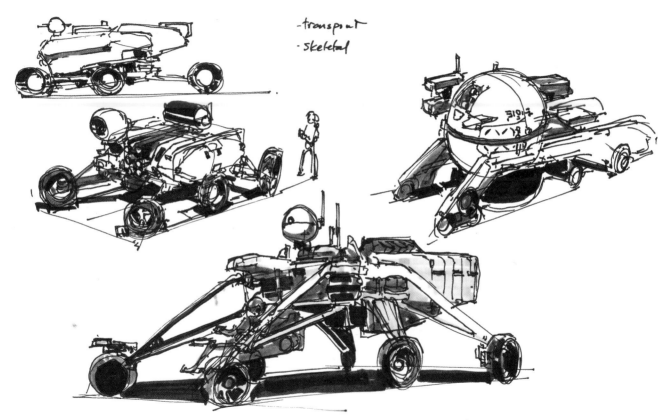

- transport
- skeletal

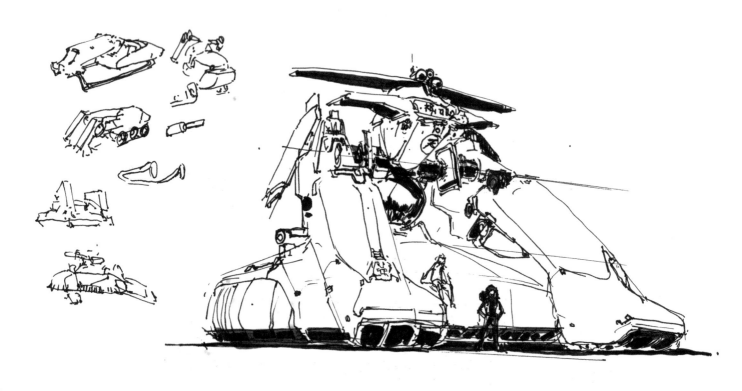

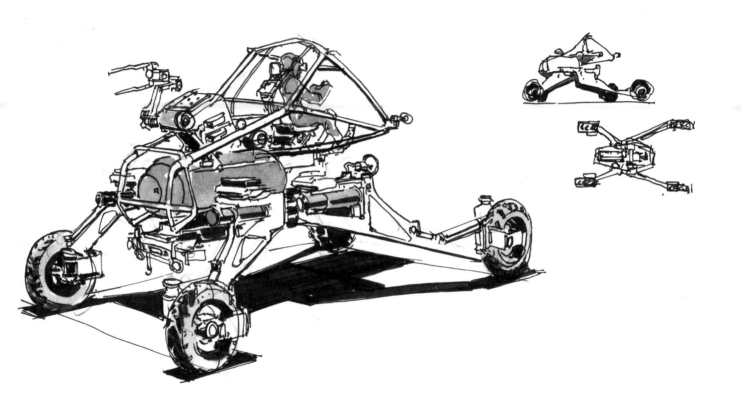

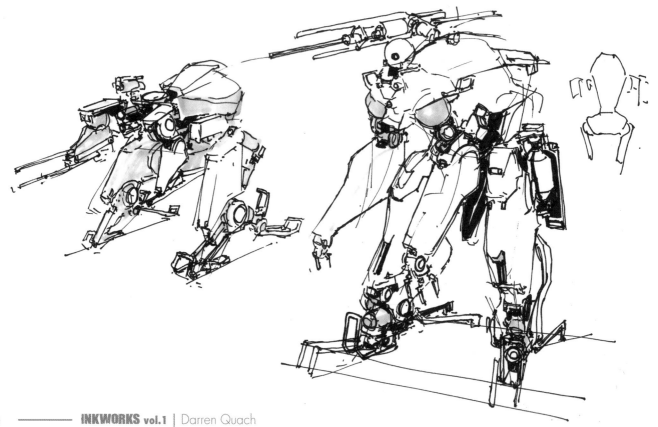

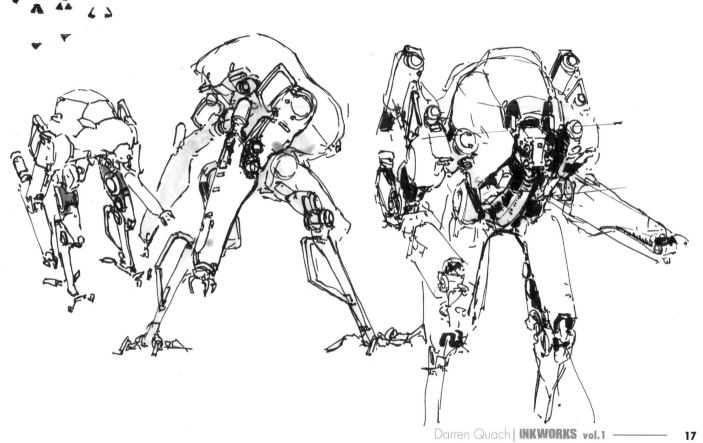

THINK of interesting ways **how** your **DESIGNS** can be animated.

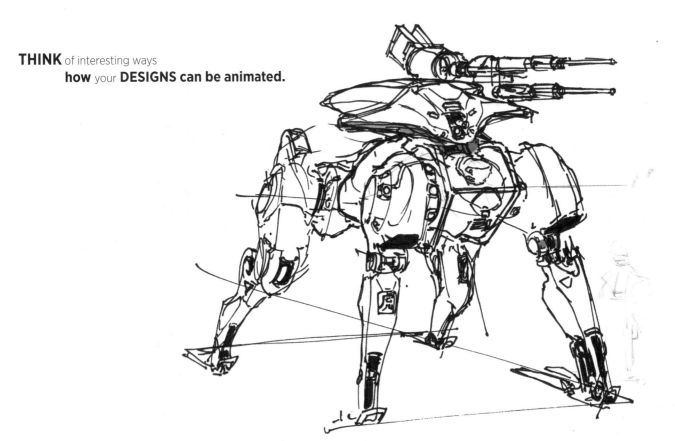

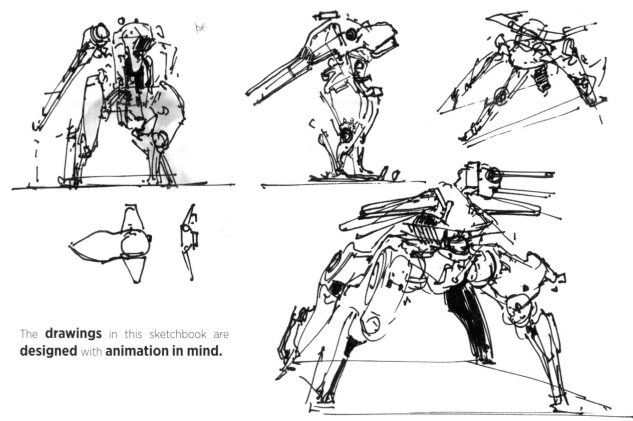

The **drawings** in this sketchbook are
designed with **animation in mind.**

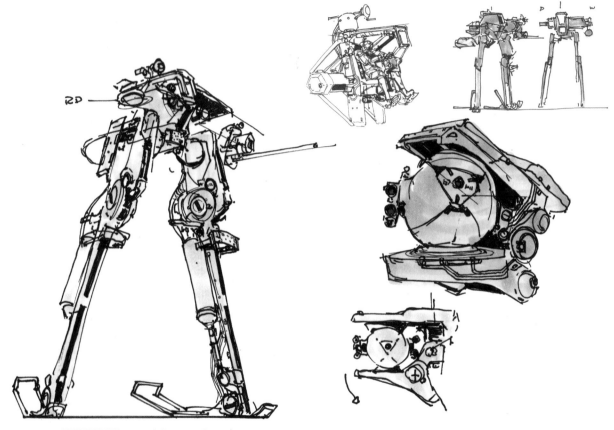

RD

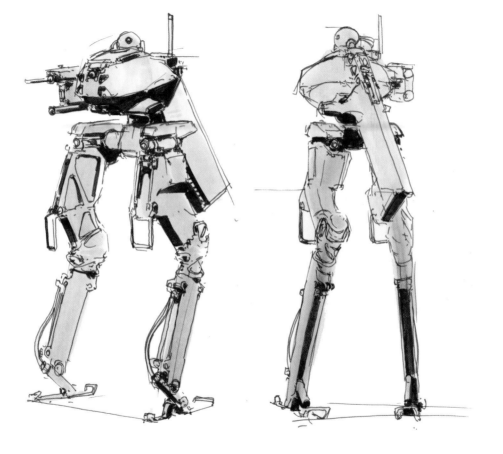

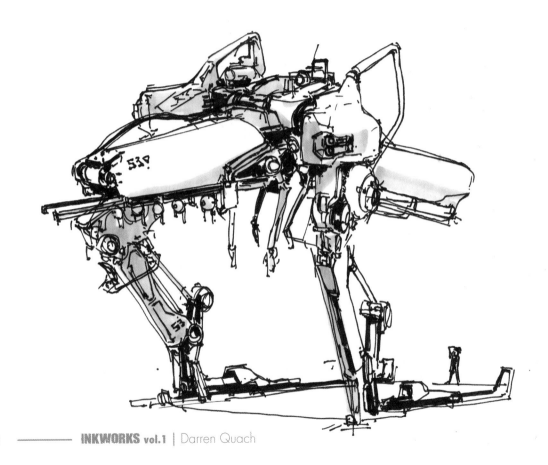

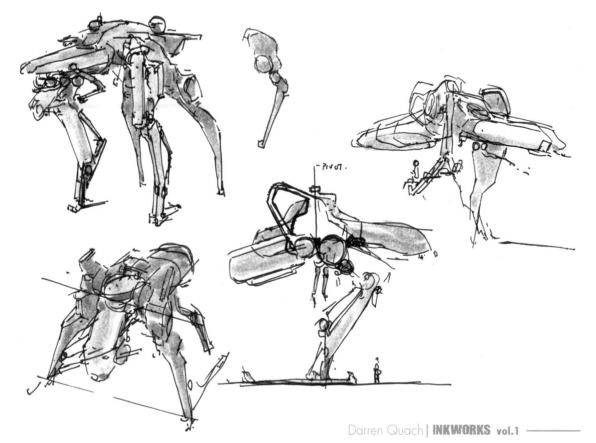

PIVOT.

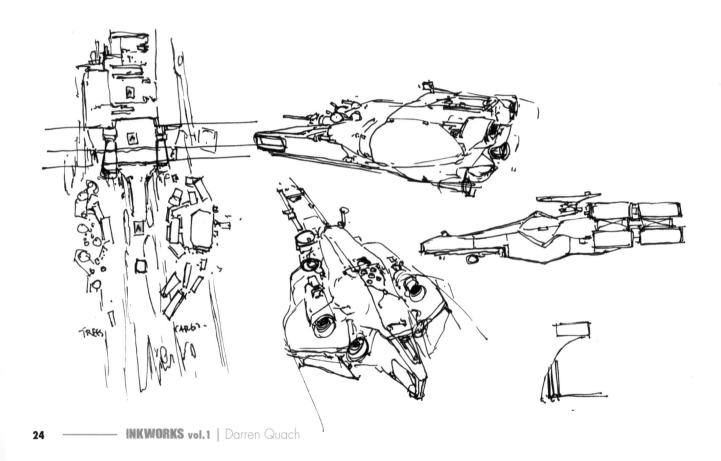

TREES

KARGO

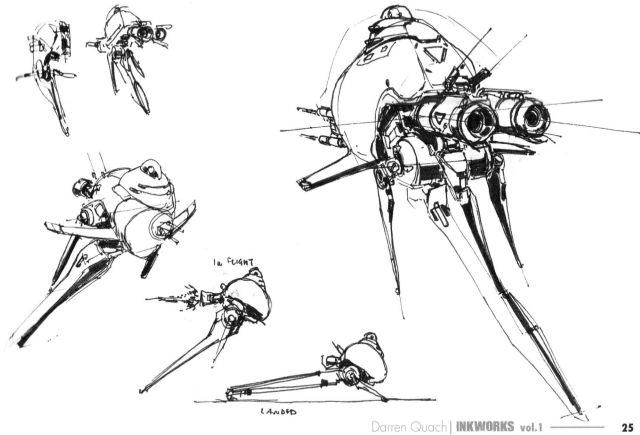

IN FLIGHT

LANDED

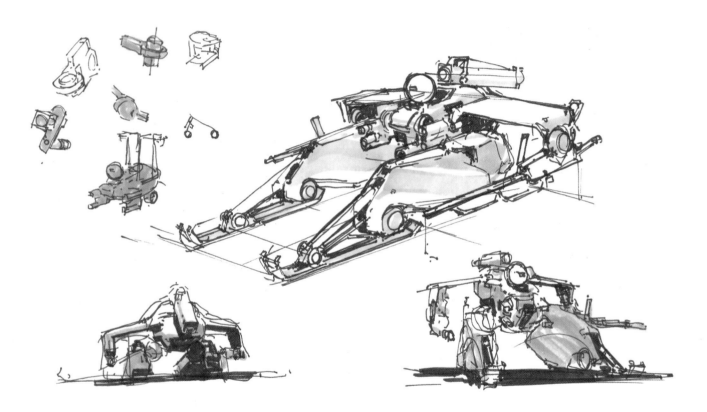

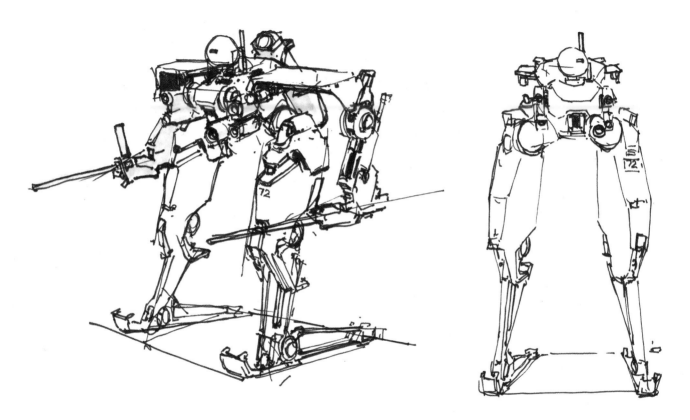

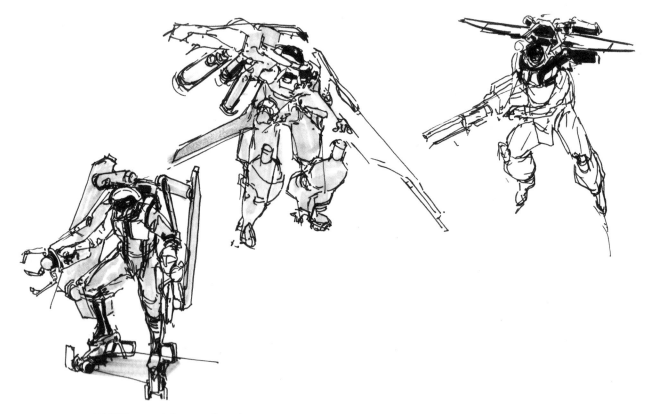

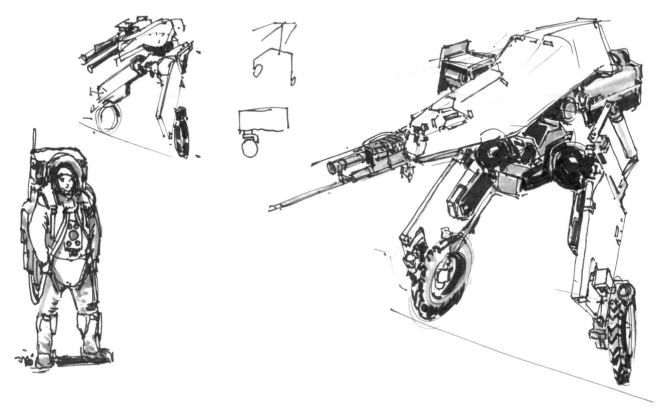

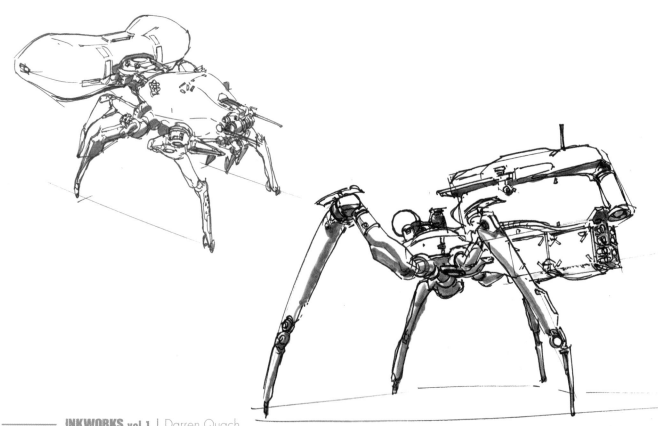

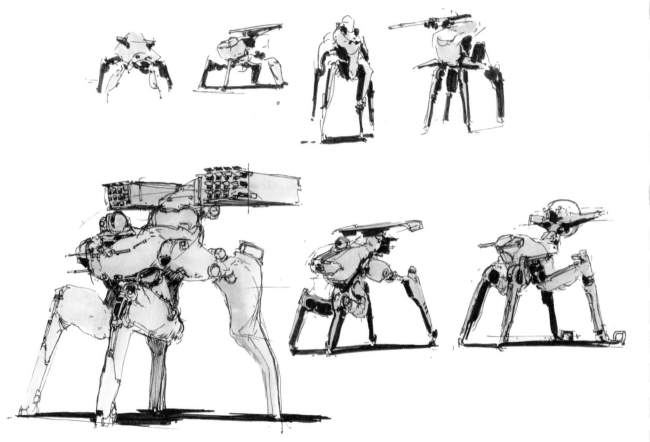

31

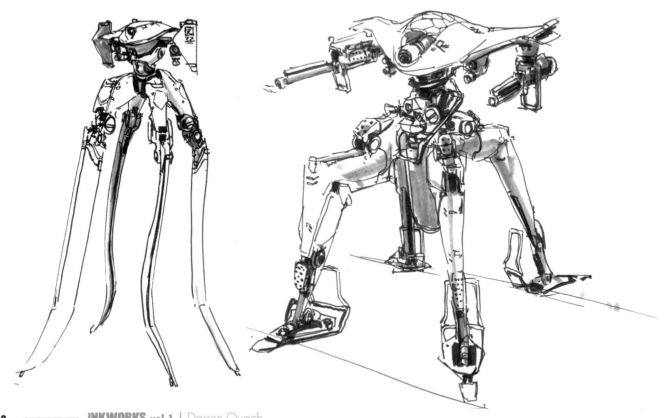

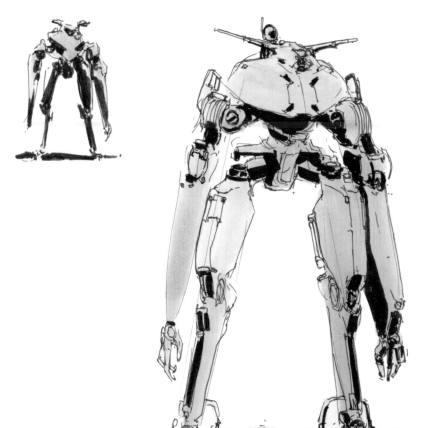

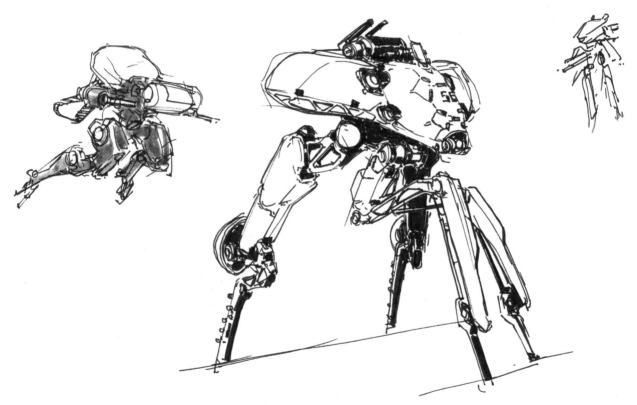

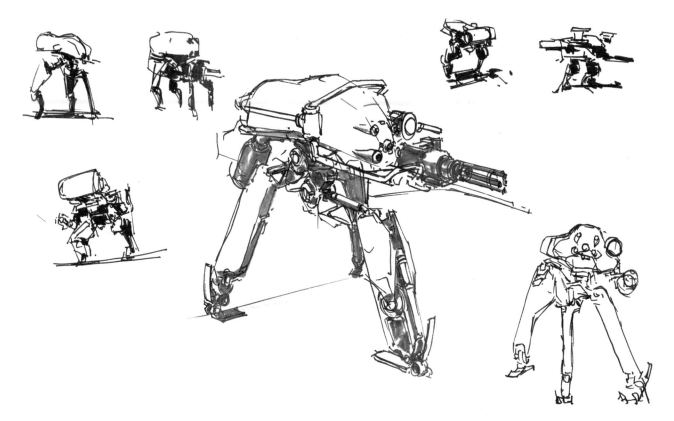

Think of the design of your **gesture**, so your forms **don't become static.**

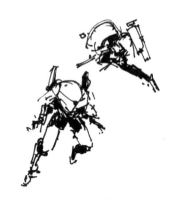

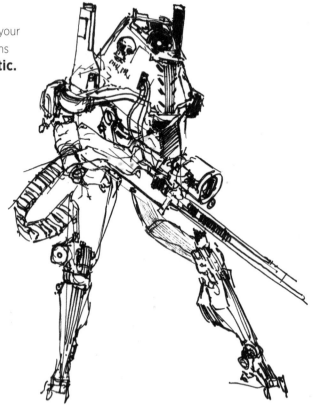

You have to **HAVE AN APPEALING SILHOUETTE,** but think of the gesture and how it will look once you have value fill.

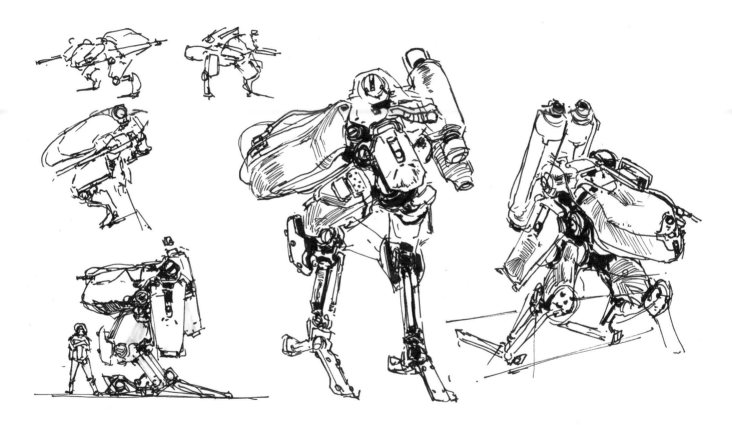

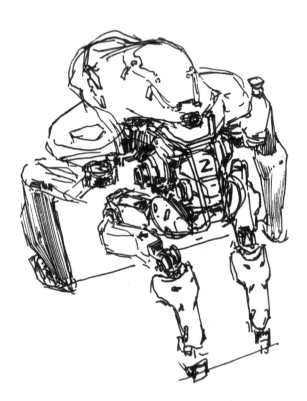
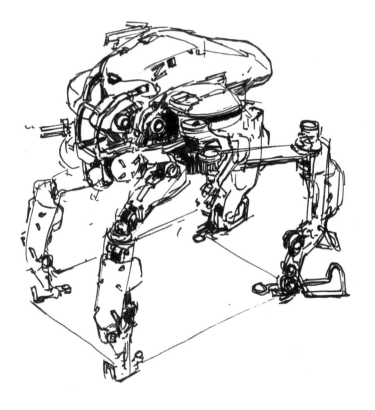

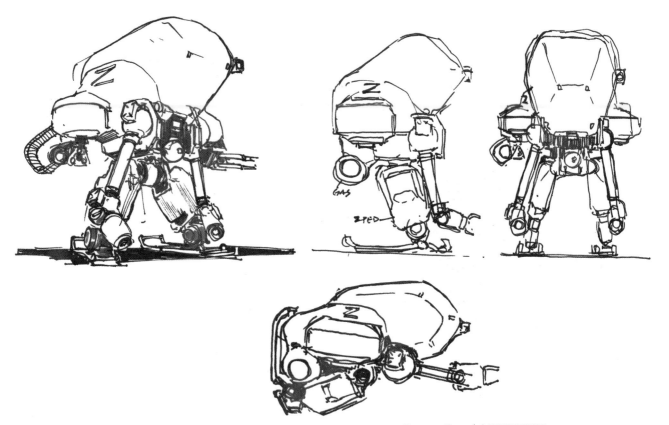

GAS

2PED

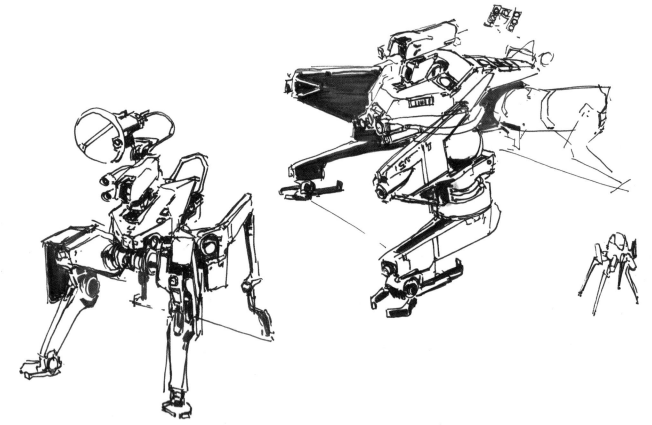

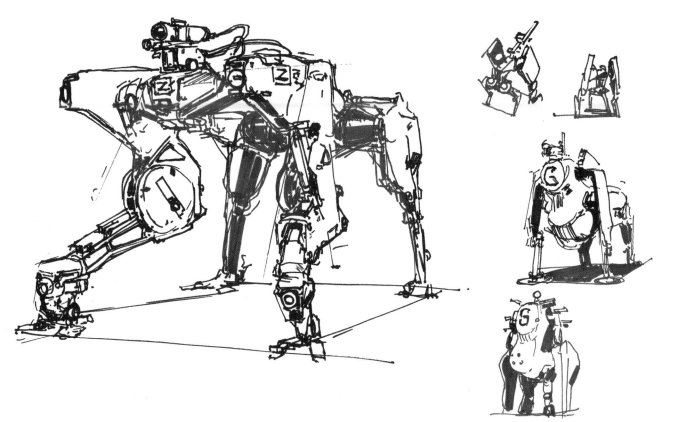

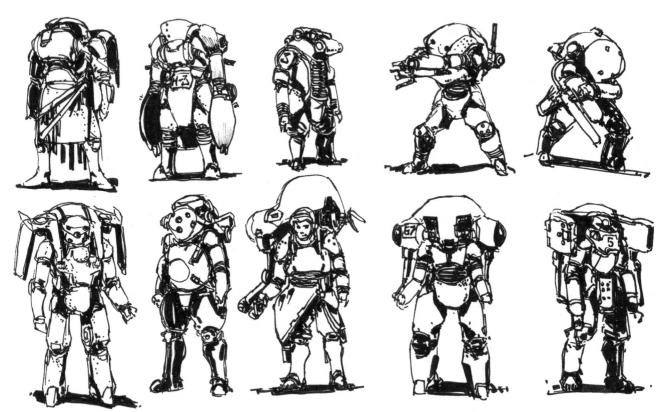

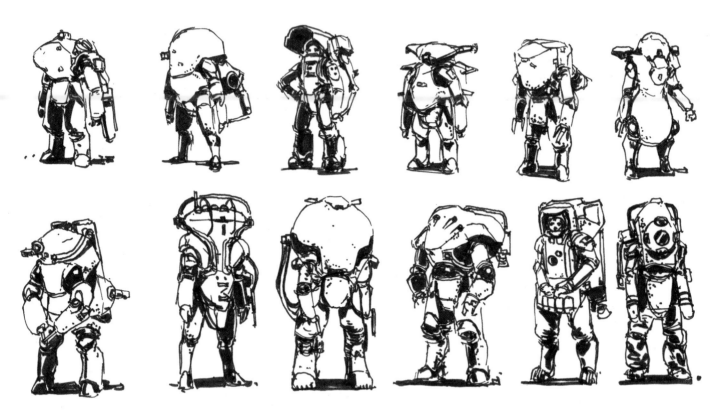

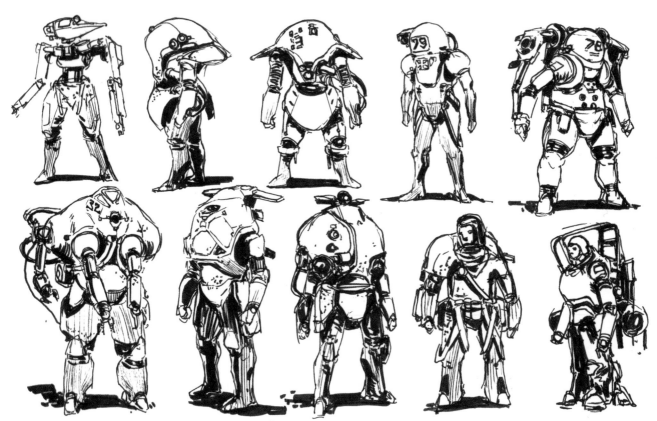

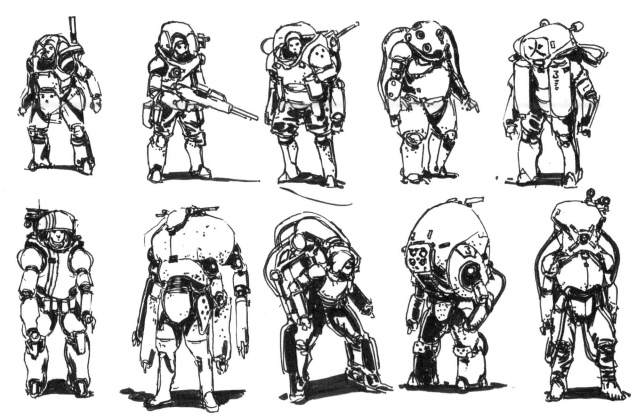

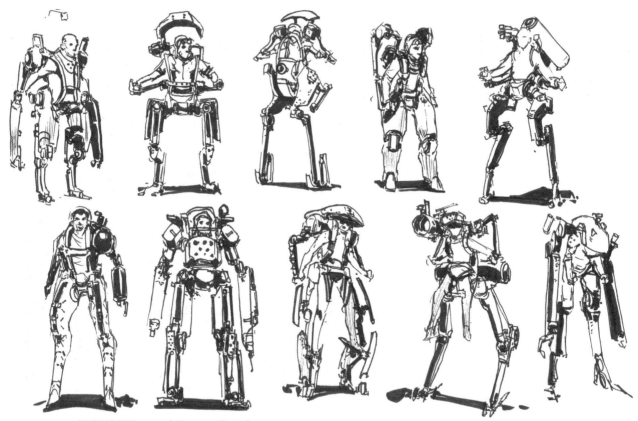

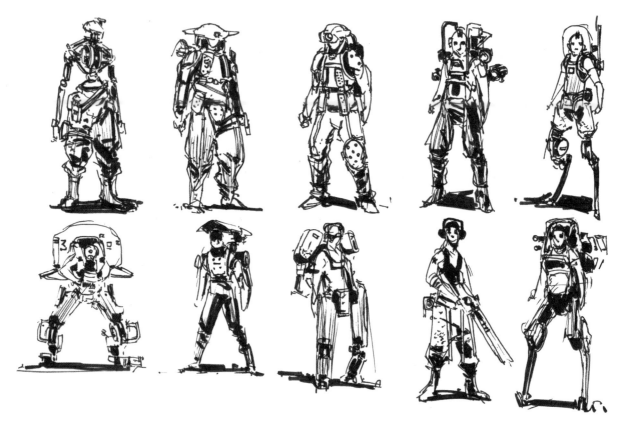

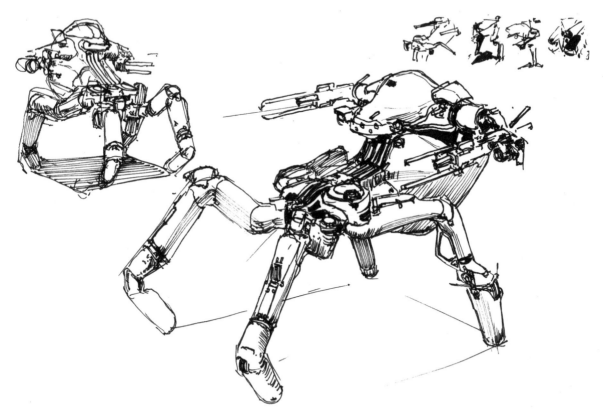

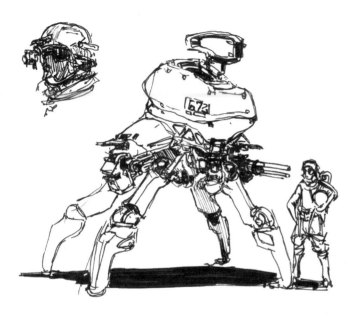
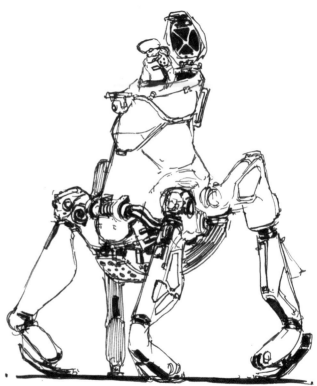

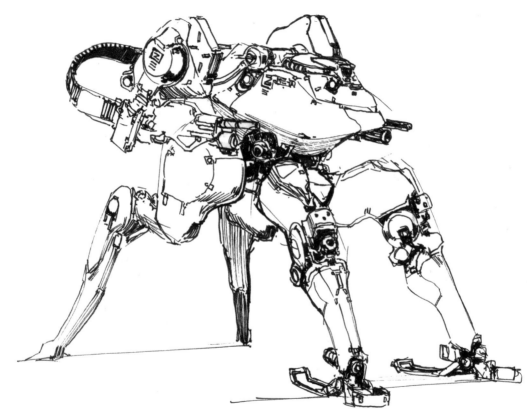

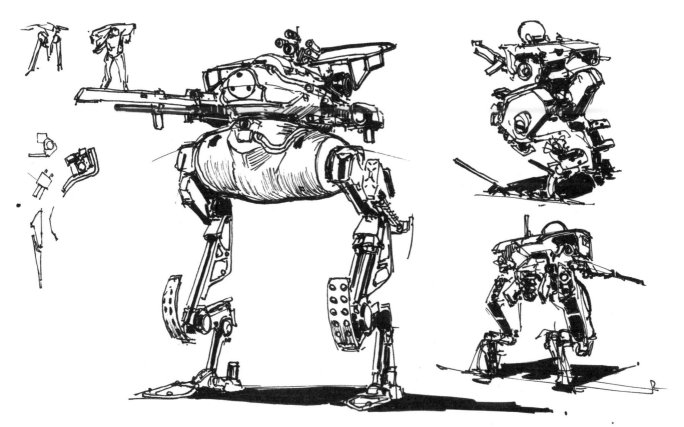

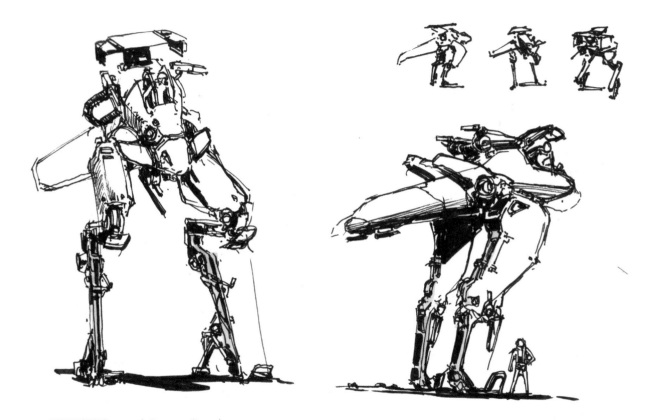

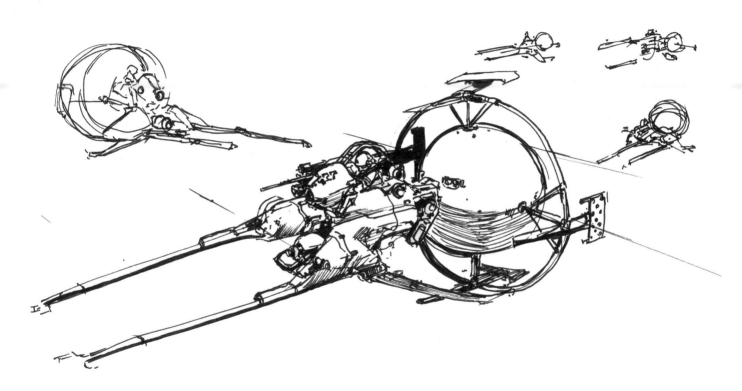

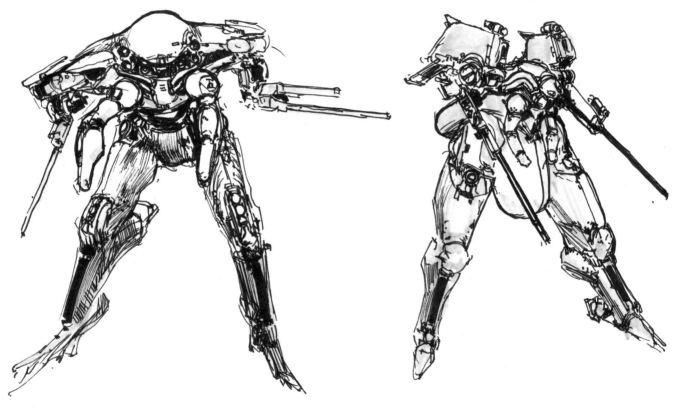

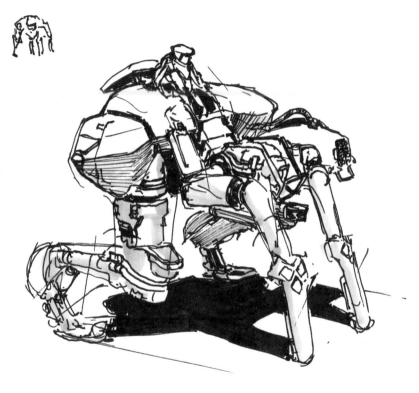
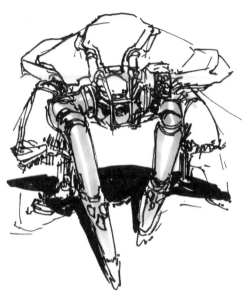

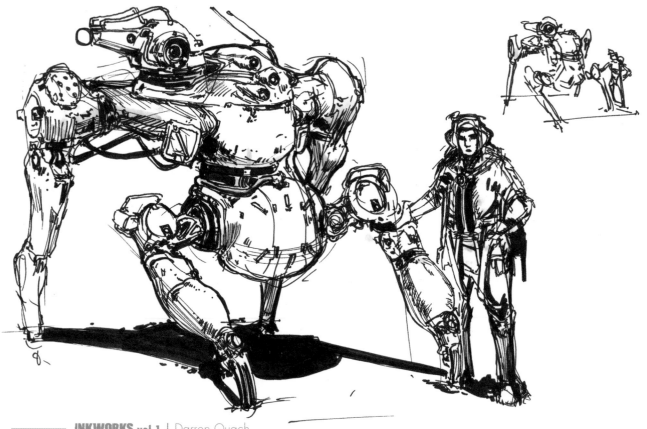

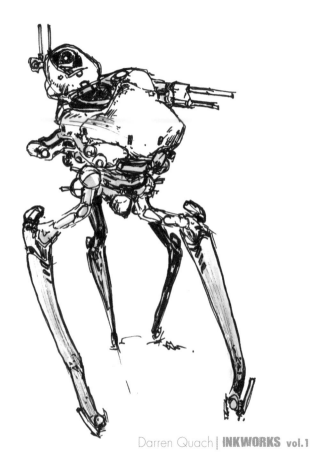

The **sketches** in this collection **are ideas** and notes **to inspire** future stories.

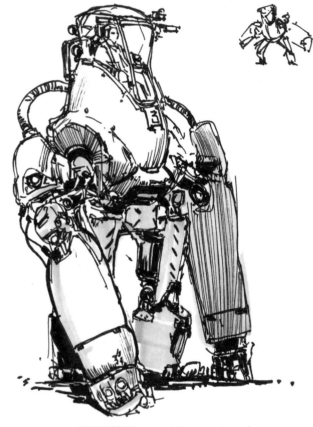
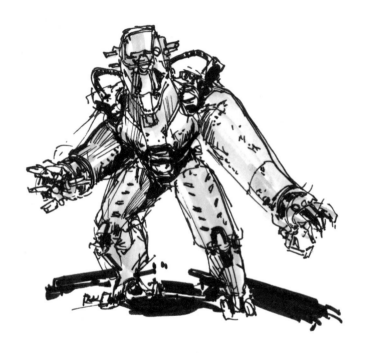

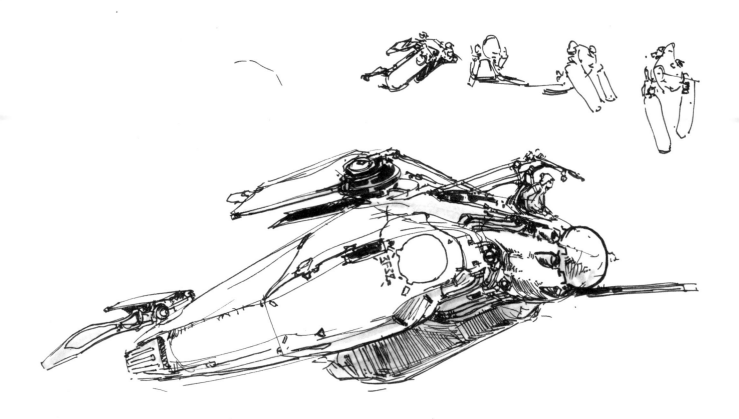

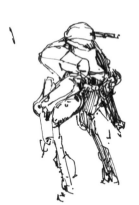
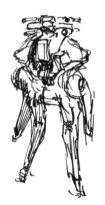
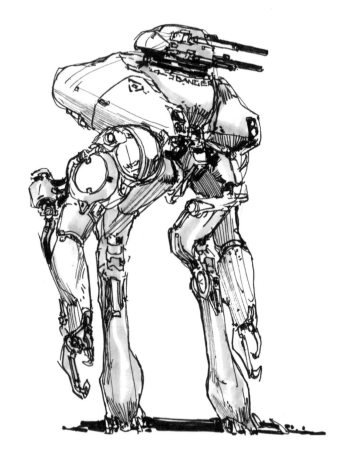

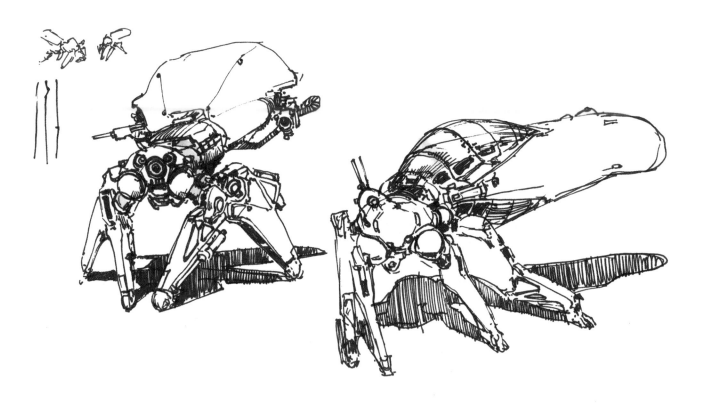

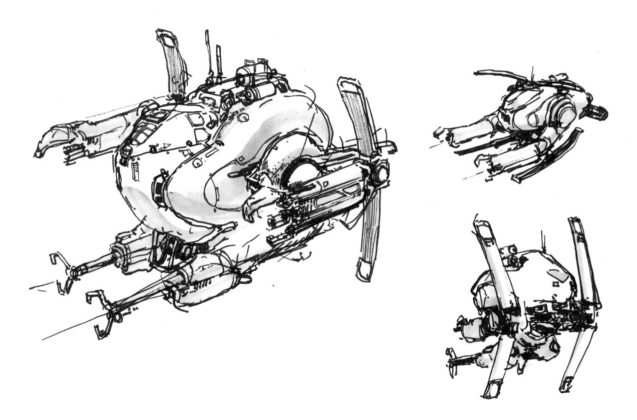

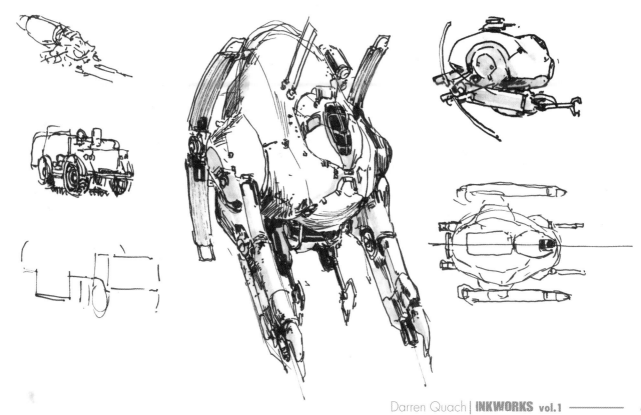

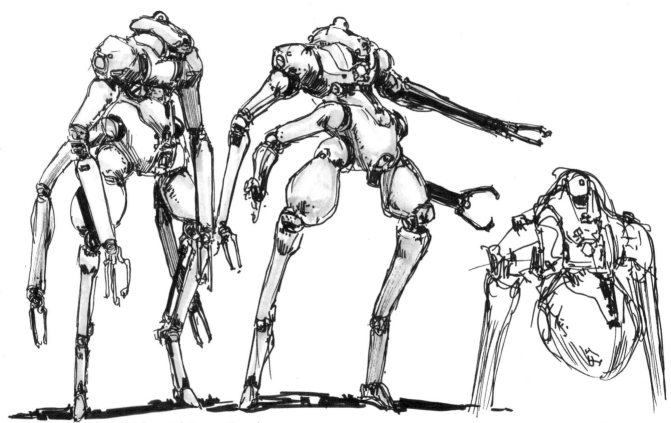

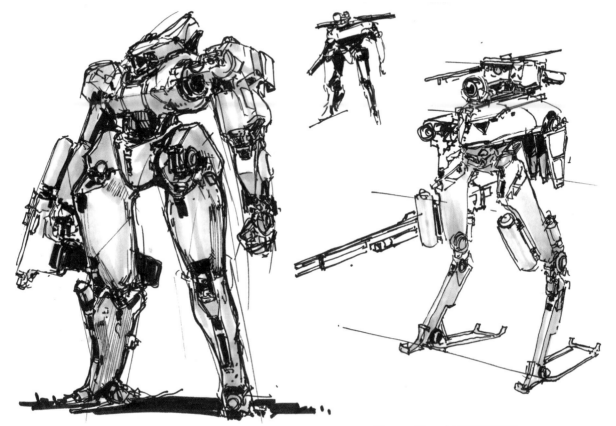

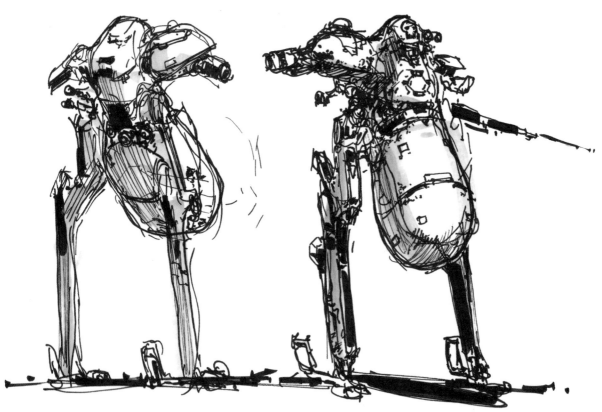

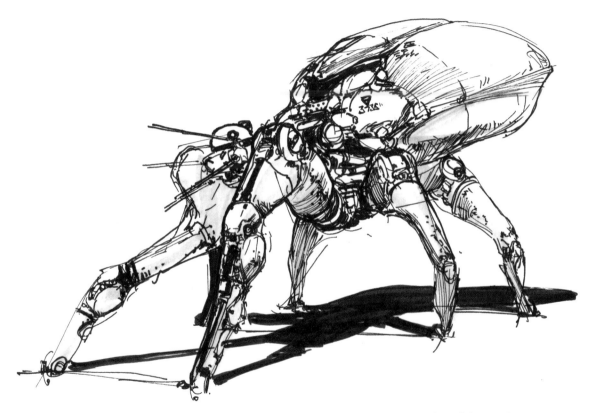

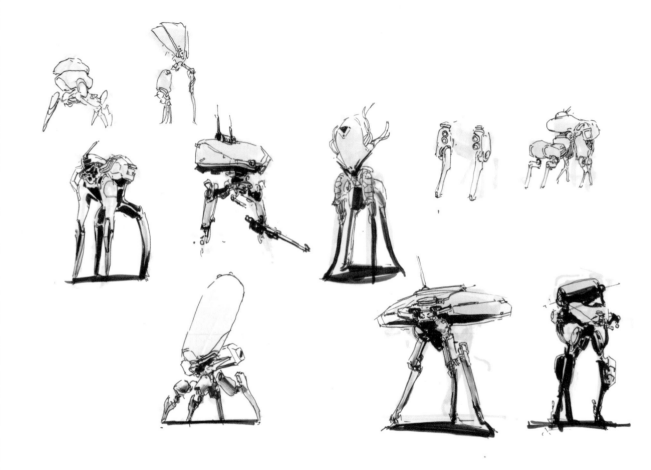

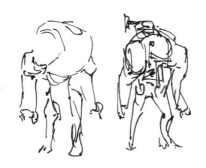
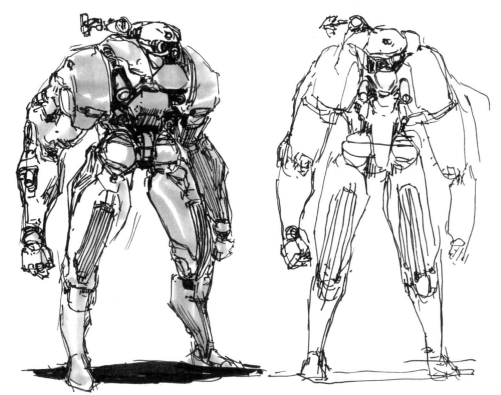

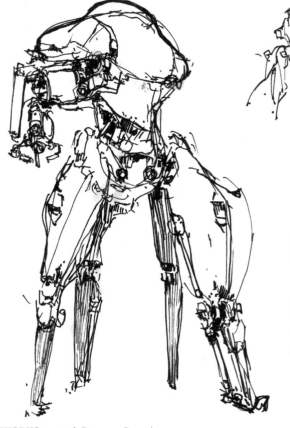

A **sketchbook works** for me **because of** its **simplicity.**

I can get started without a PC.
Just **flip to the next** empty **page**,
grab your pen, and **you're ready to go**.

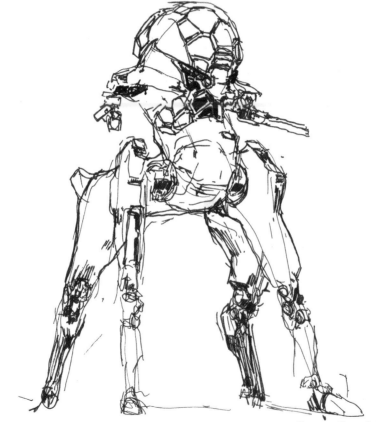

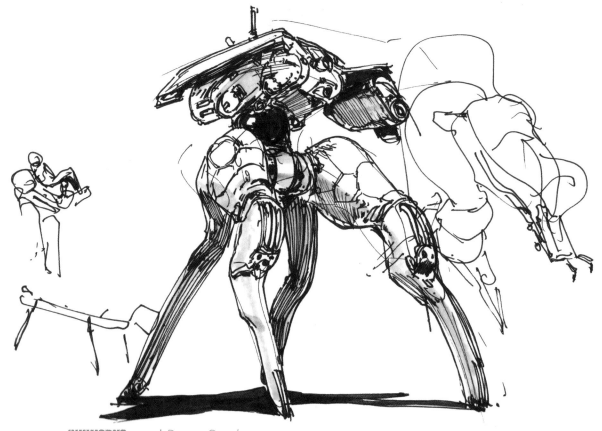

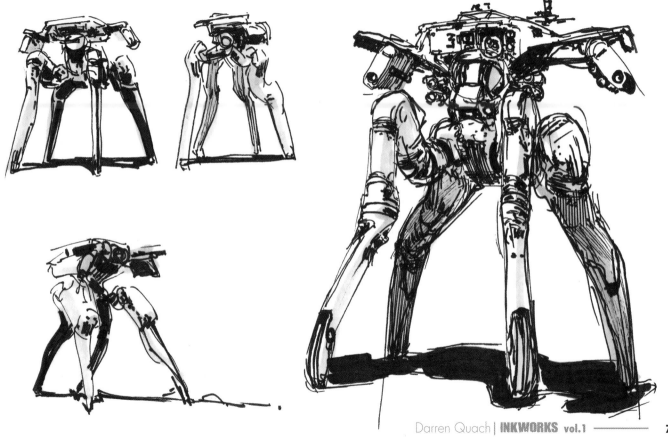

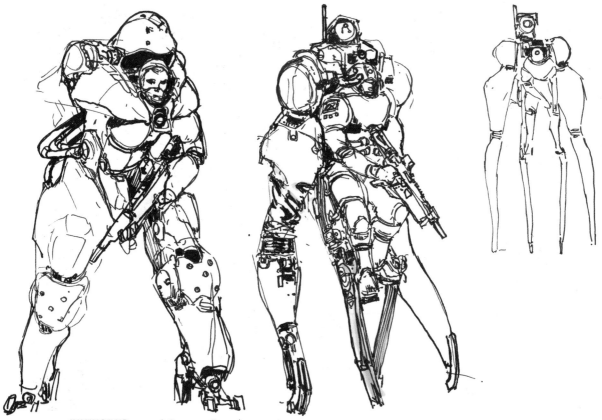

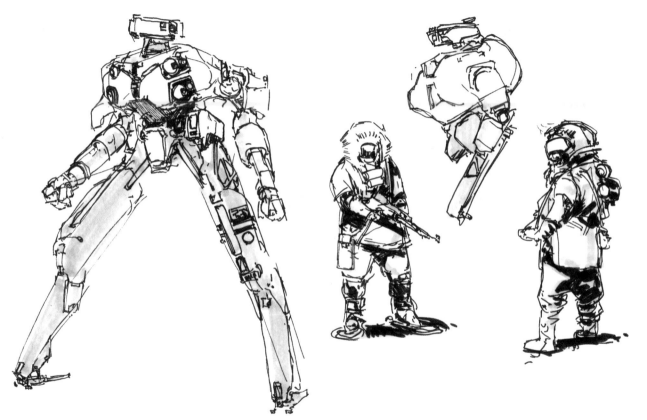

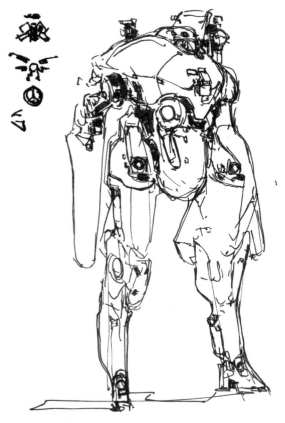
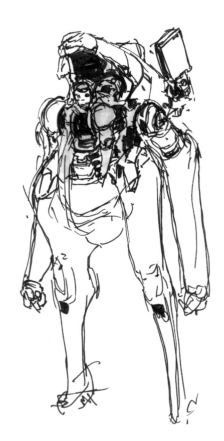

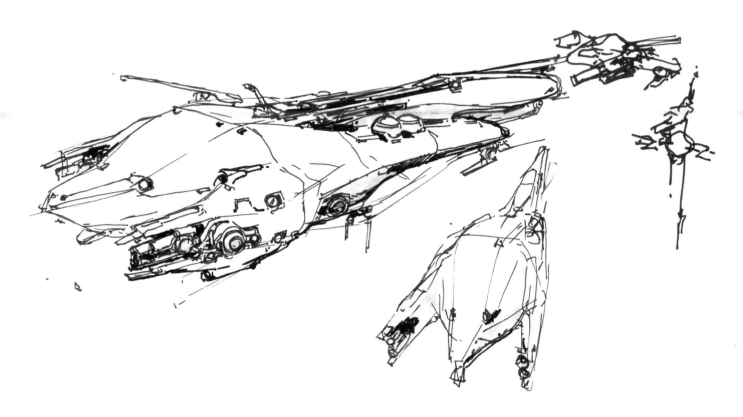

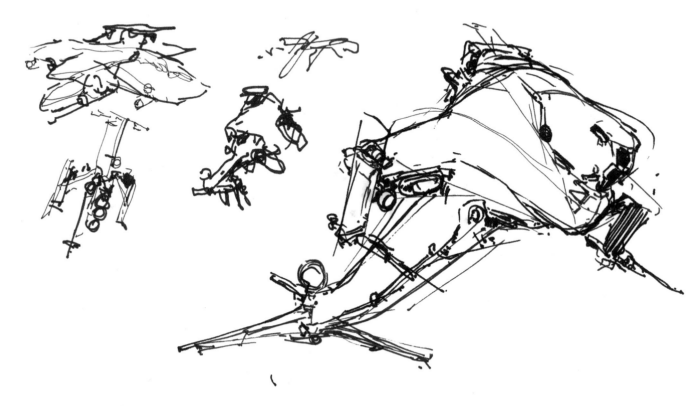

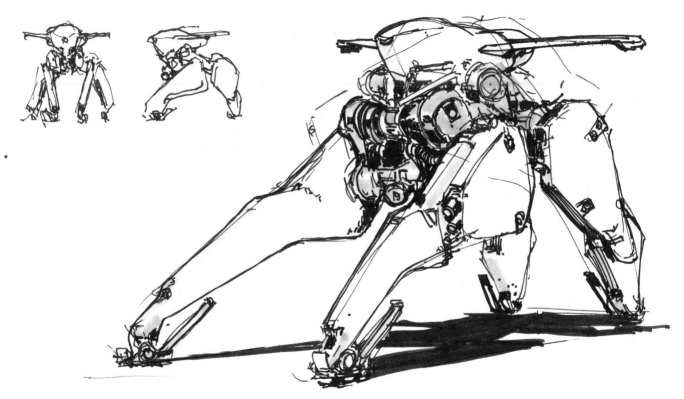

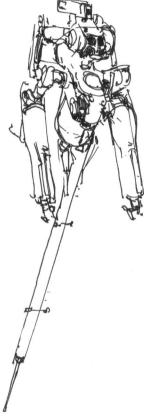
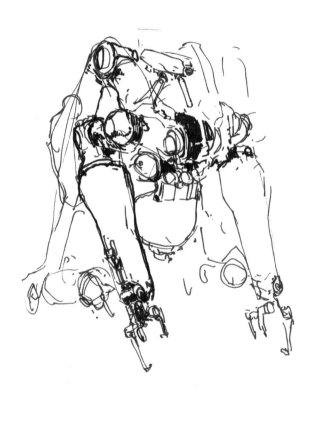

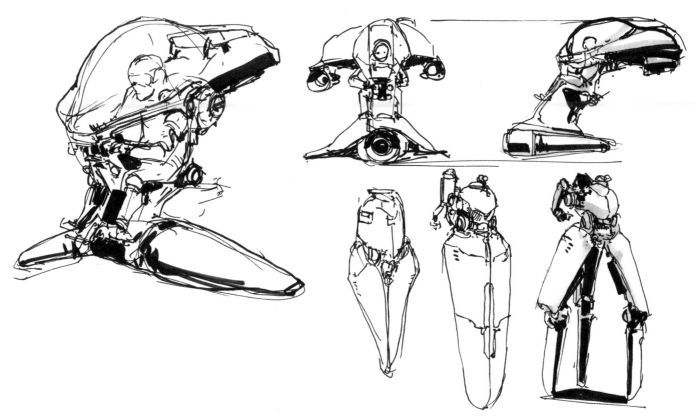

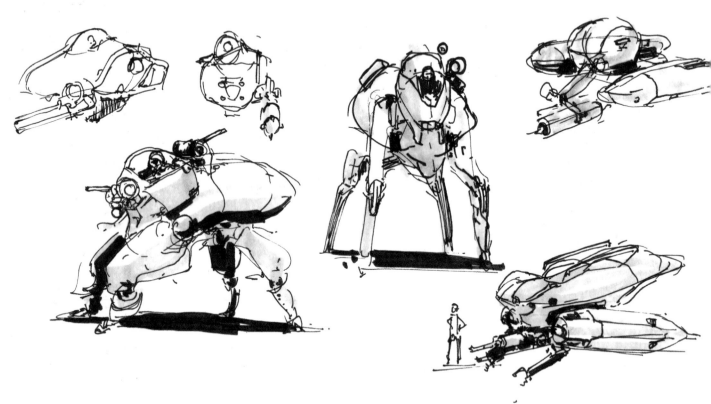

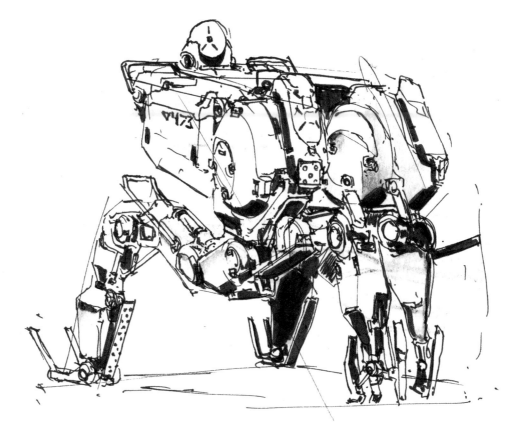

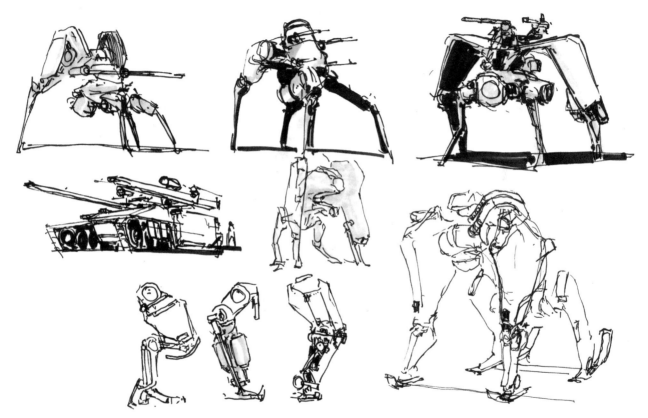

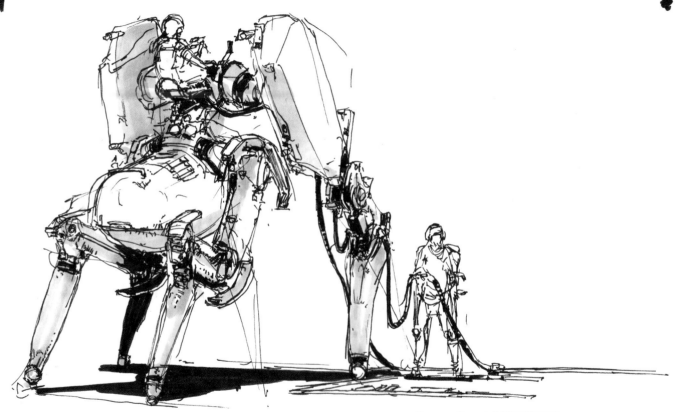

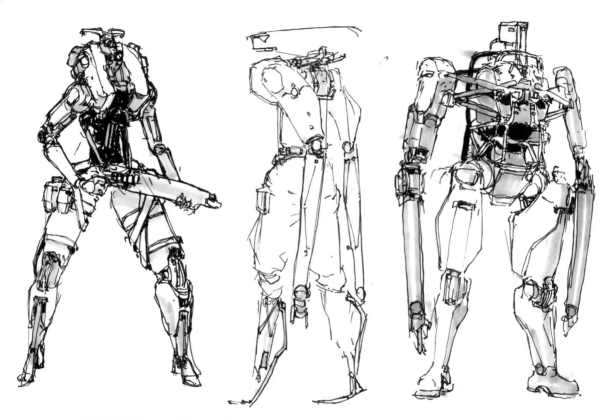

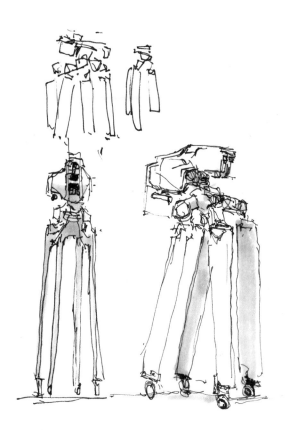
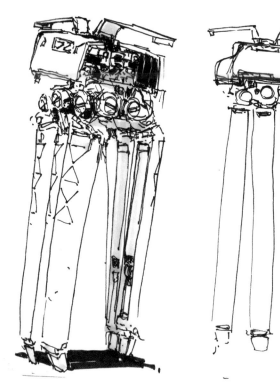

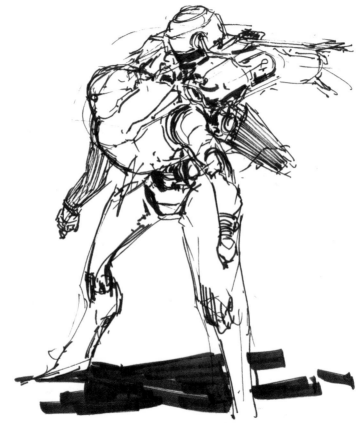

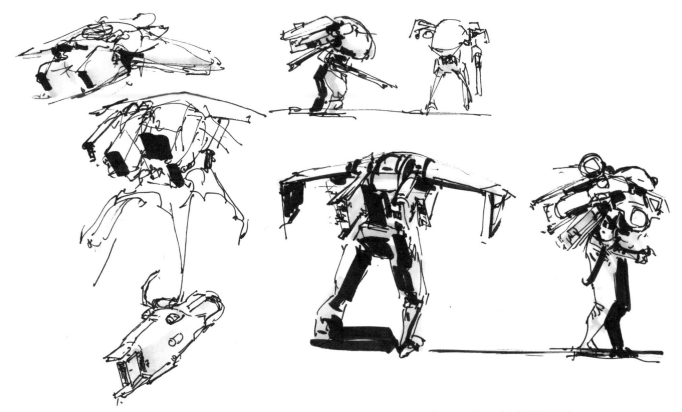

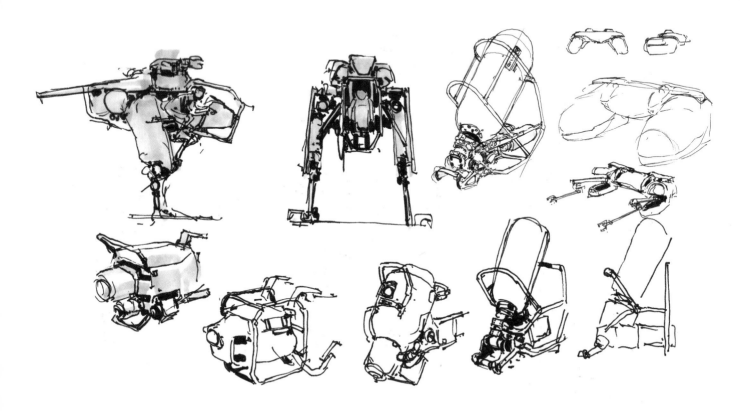

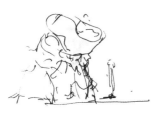
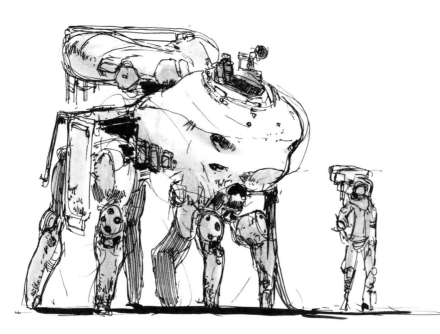

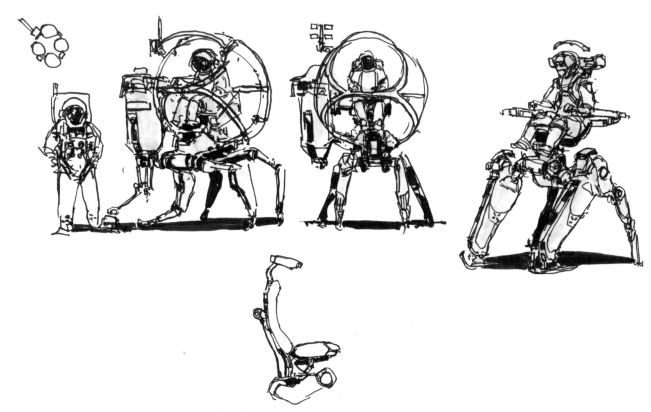

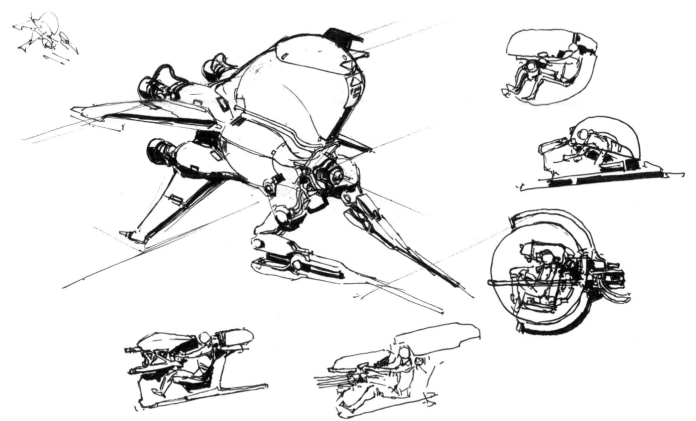

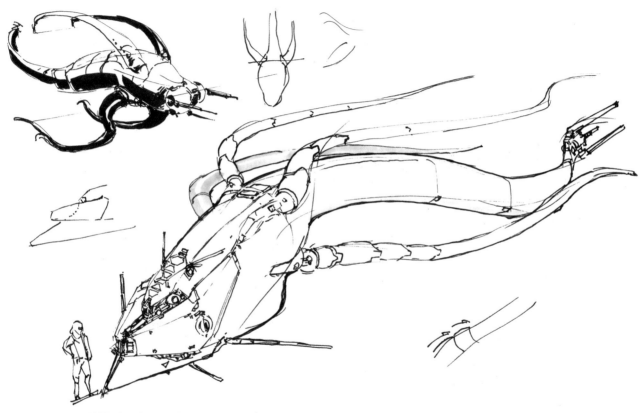

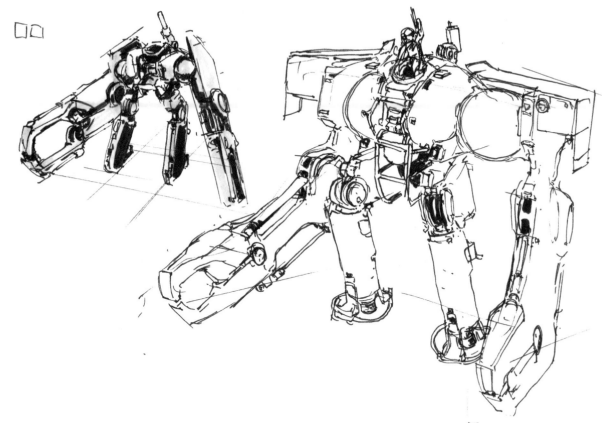

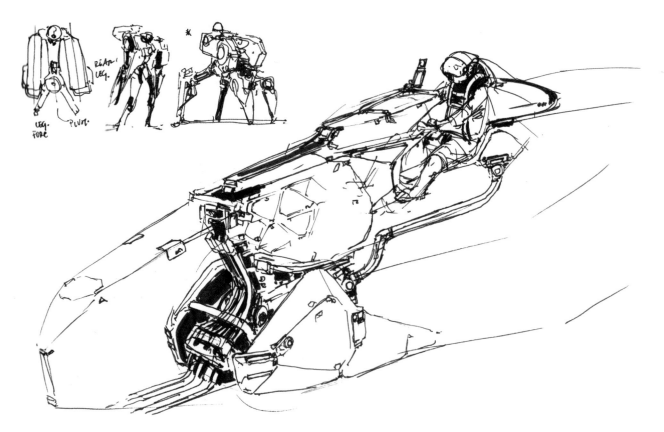

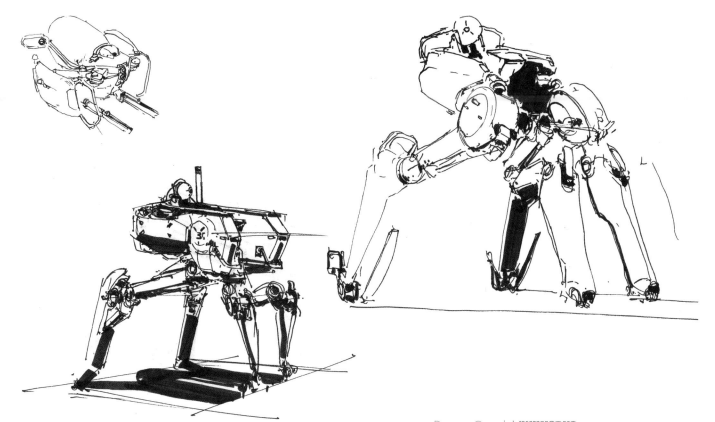

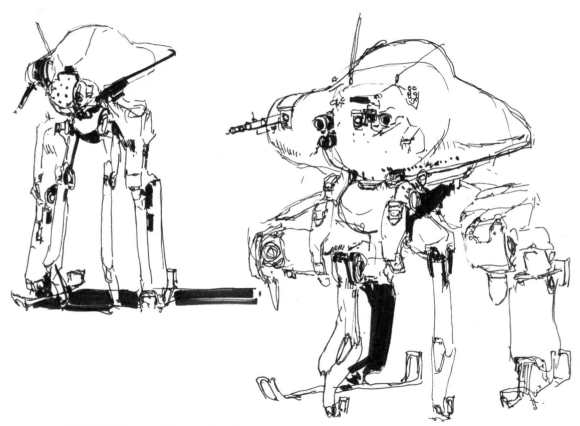

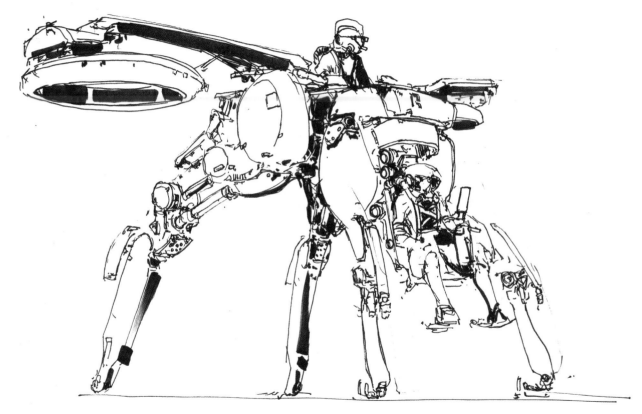

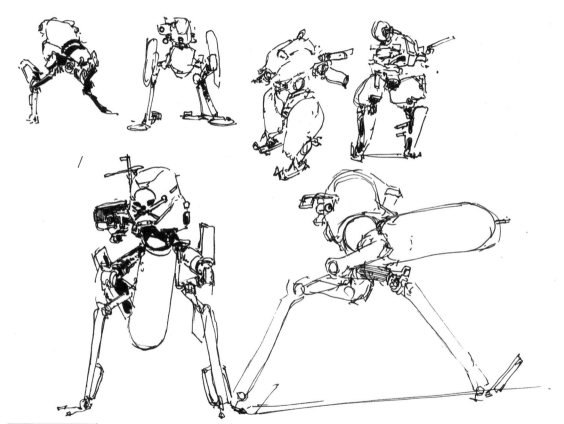

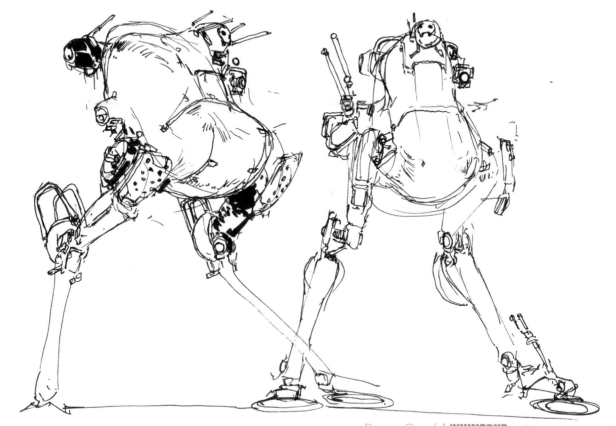

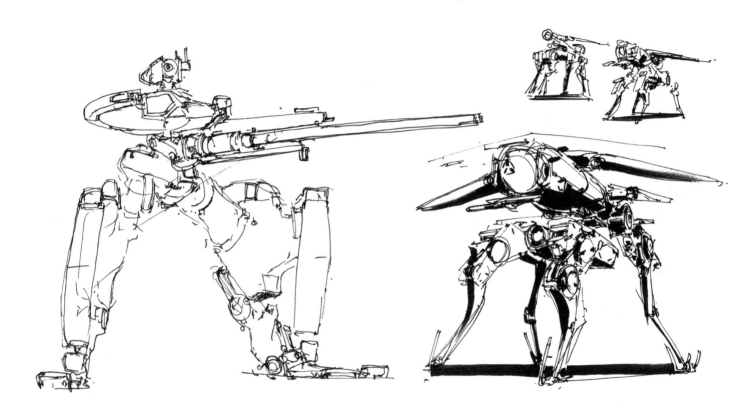

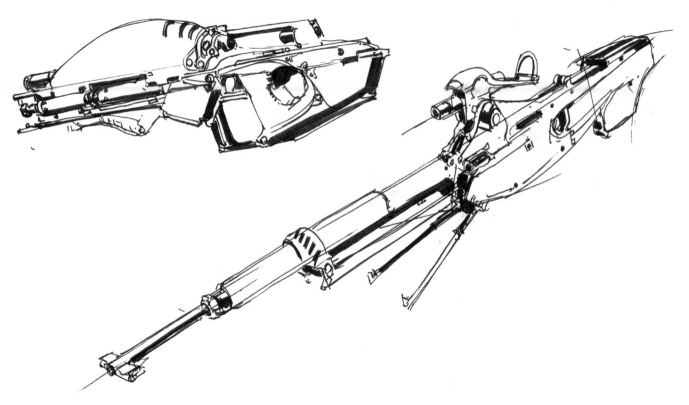

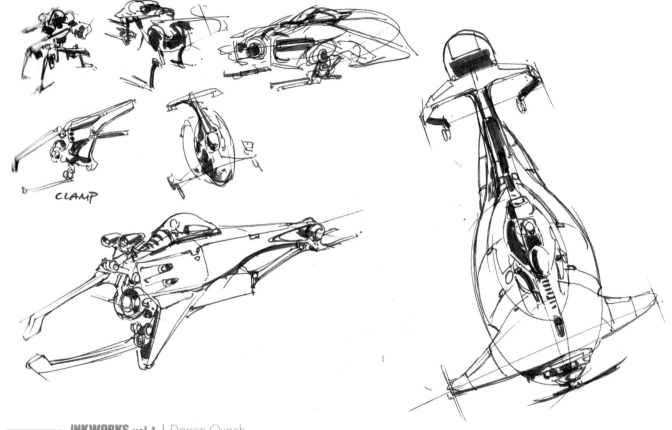

CLAMP

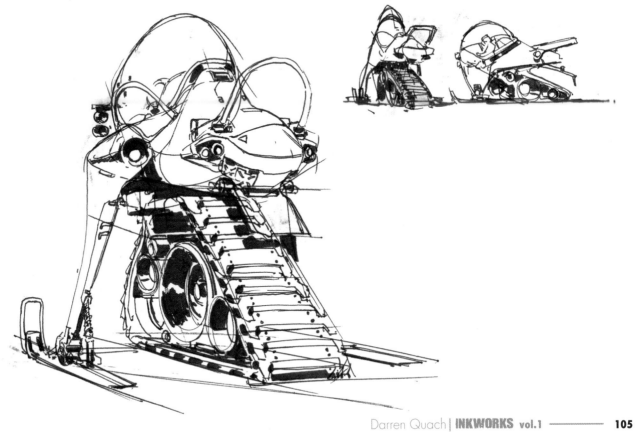

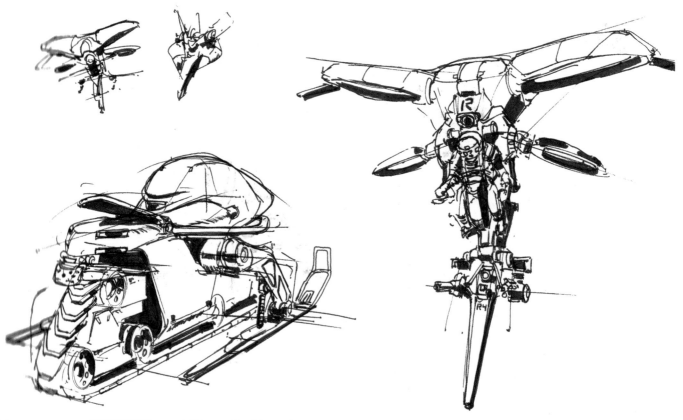

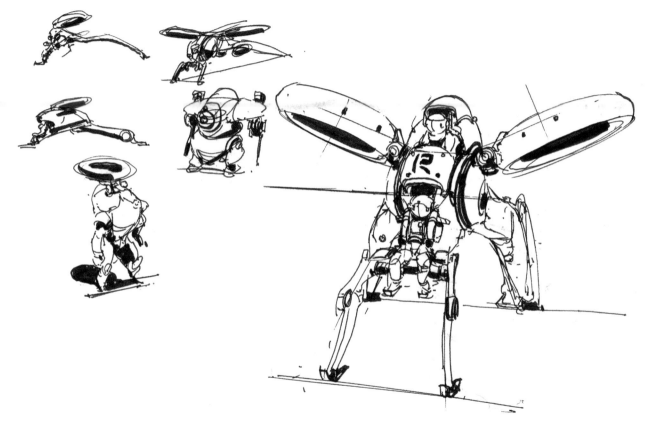

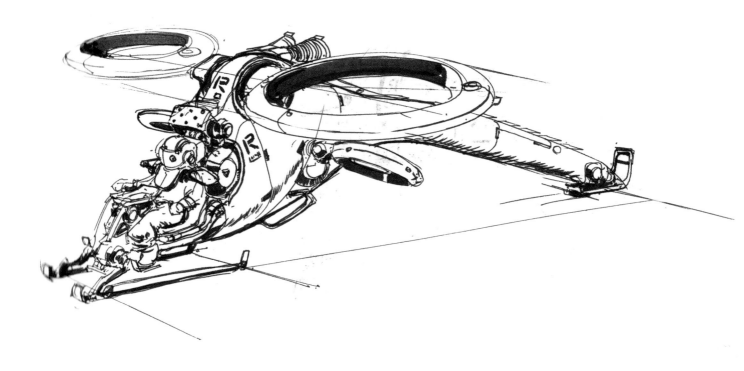

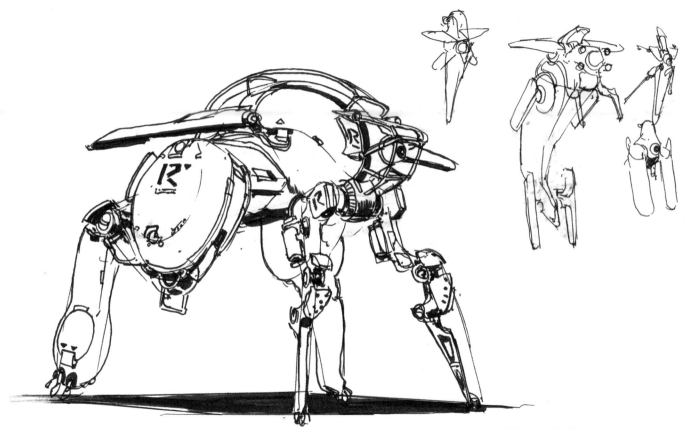

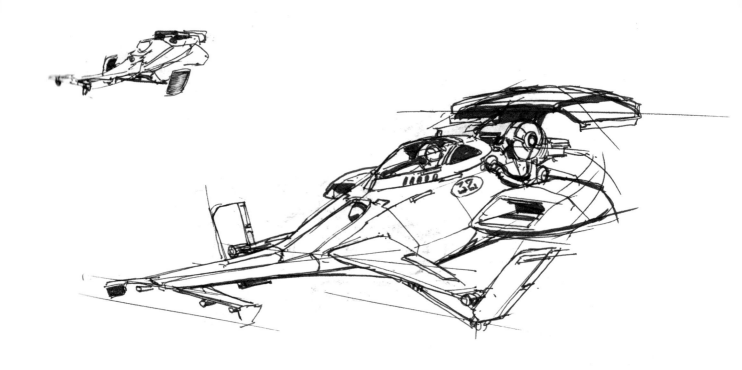

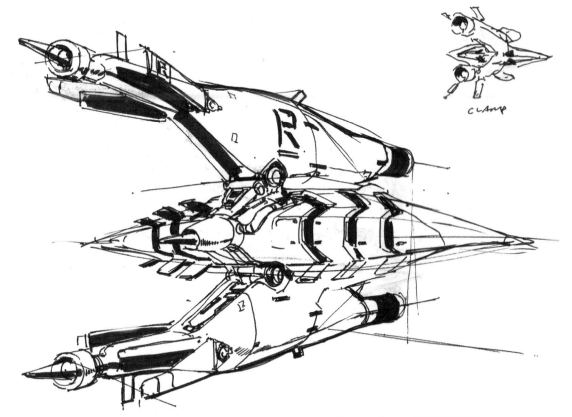

CLAMP

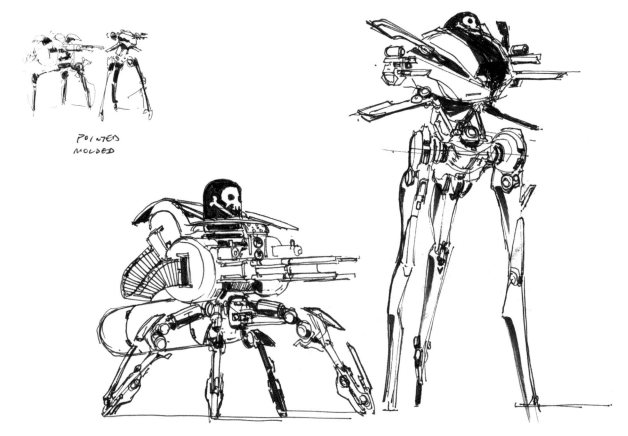

POINTED
MOLDED

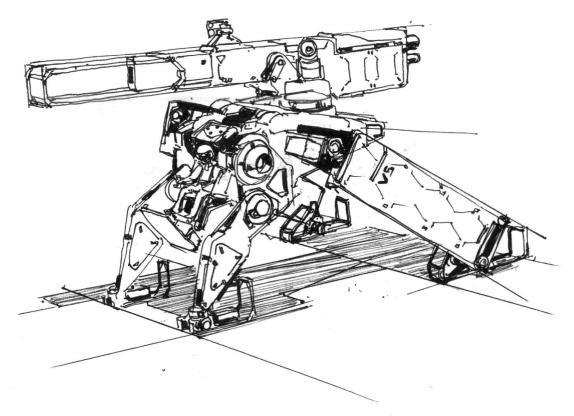

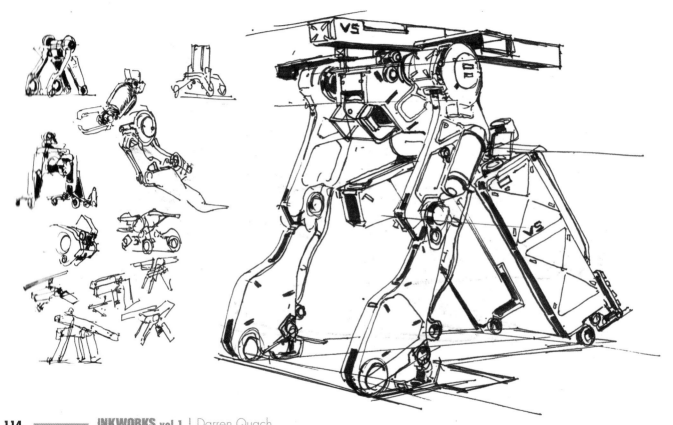

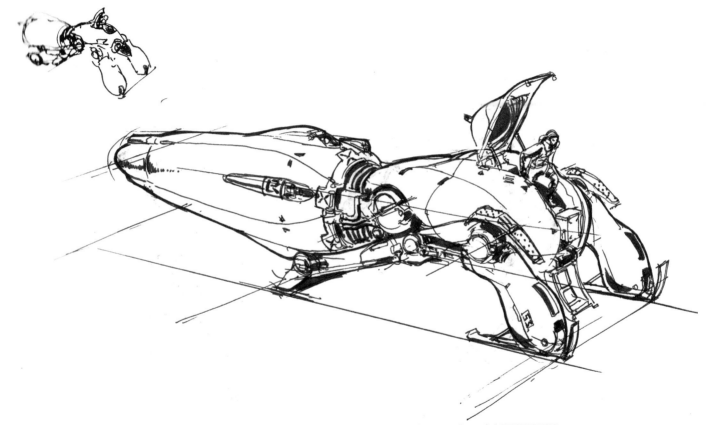

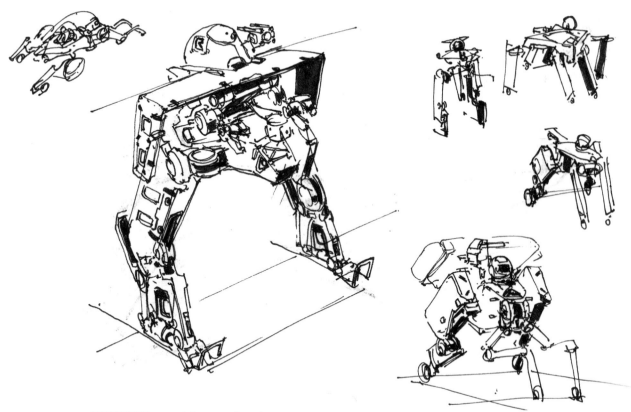

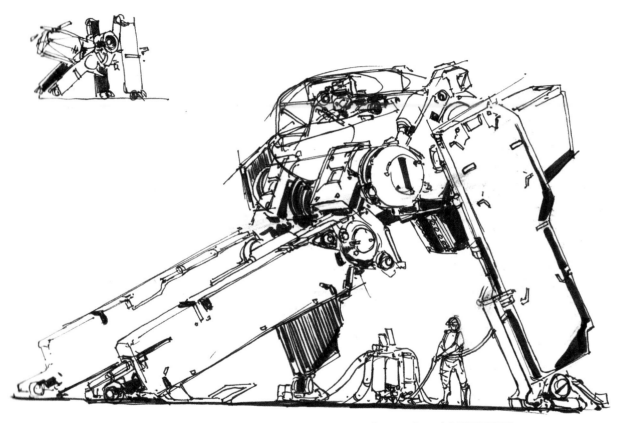

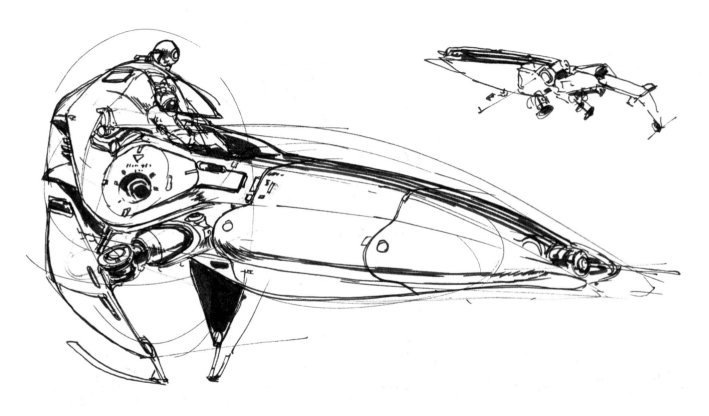

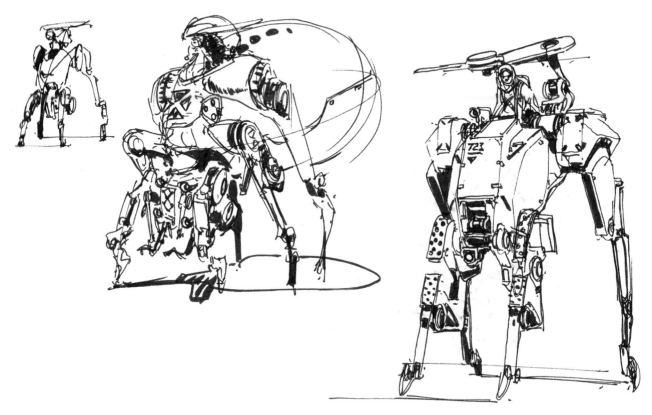

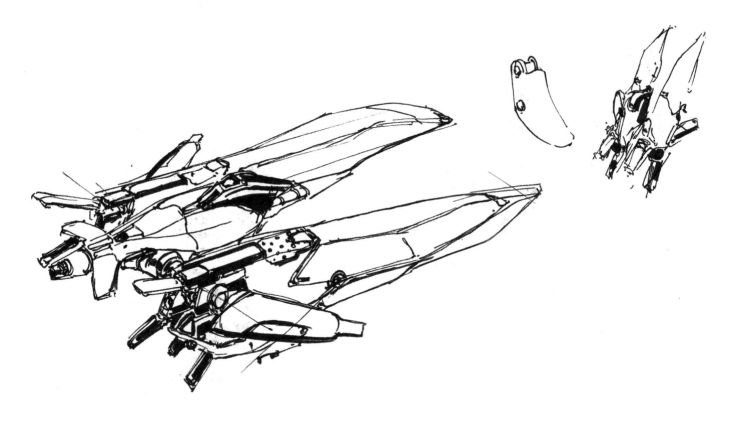

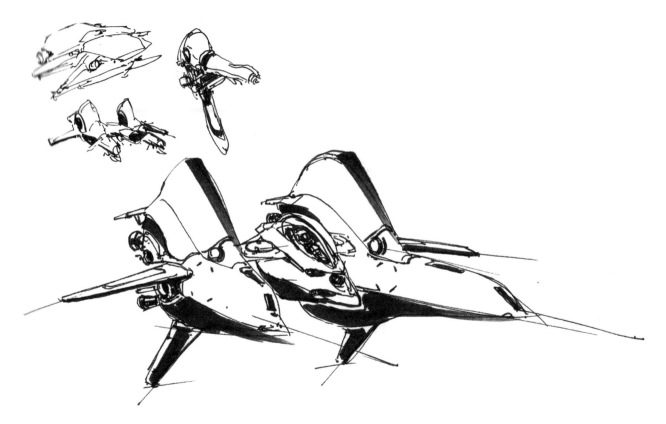

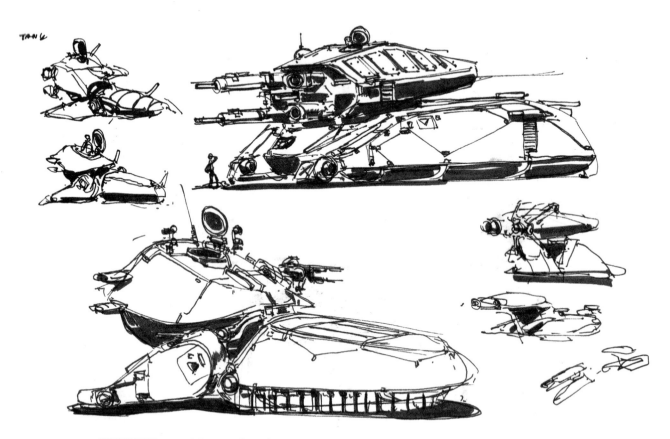

TANK

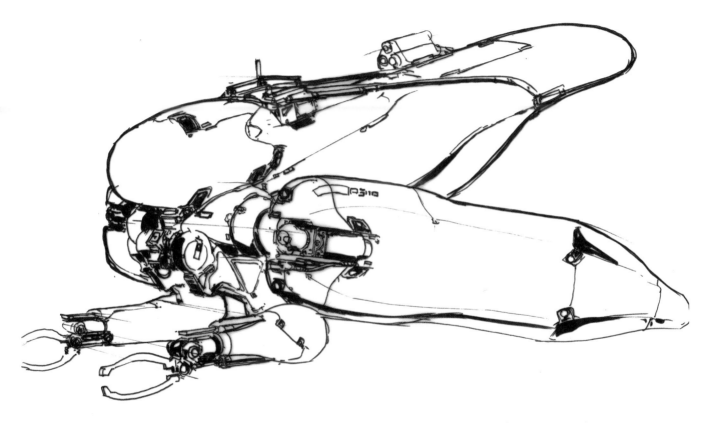

A Conversation with Artist **Darren Quach**

What was the impetus behind this sketchbook?

I challenged myself to just draw in a sketchbook because it is really immediate and it's a good break from my digital work. I think in this digital age we're so used to being able to step back through our "histories," but there is something about the immediacy of these drawings that forced me to slow down and really consider the marks that I was putting down.

When I'm working digitally, it's easy to get caught up in the digital tools, and sometimes I find myself losing focus on the design. That is not so much the case when working traditionally, which I feel tends to make you more aware of the marks that you are putting down on paper. So, for me, drawing in a sketchbook was an effective way to gain more design experience.

What do you want people to get out of your book?

I hope that people gain some insight into what concept art can be as it's developing. I'm hoping that they get the sense that these designs can be the start of more design explorations. Beyond that, hopefully they enjoy the variety, and then understand that this is the early part of the design process, one that is rooted in a strong foundation. Eventually, I hope this book inspires more artists to continue drawing and developing their design sensibilities.

What do you like most about the sketching process?

This is the only opportunity I get to sit down and just work in analog again. It's not flashy, it's just about getting your ideas down. And if you can get a strong enough impression, that's what catapults you to a more refined design.

Do you think of a story or character as you sketch?

The mechanical and character sketches in this book really started out as simple design exercises. In a way, I'm testing to see what kinds of form languages I can get, at the same time, I feel like building a stockpile of designs to inspire future stories.

Tell us about the characters on pages 42-47.

These are just little miniature studies. I sat down a couple of nights after work and just sketched these out. It was really fun just drawing a set of multiple characters on one piece of paper. It's a great design exercise as you can see them all in context. Sometimes we as artists work on just one design and close it, or put it aside and start something else, and eventually they all start to look the same. This exercise allows you to compare all your designs, and makes it easier to iterate and come up with unique designs.

What pens do you generally use?

I prefer to use Staedtlers pens, Sharpie markers, and brush pens.

Do you have a drawing regimen?

With a lot of professionals I know, they work 8-10 hours a day, so that's sort of their regimen already. I would say for a student,

I'd suggest just getting used to having a pen out. Make it as easy as possible. And I think that's why a sketchbook works so well, because you don't have to power your PC, open up your files, and get all of your stuff. Just flip to the next empty page, grab your pen, and you're ready to go.

Do you have any sketchbooks from when you were a kid?

No, I drew on furniture . . . and walls. That didn't work out so hot.

How important do you think sharing this stage of the creative process is?

I was talking with John Park at Adhesive Games while we were working on *Hawken*—we teach classes as well—and we realized that this is a really important part of the process that not a lot of people outside of the industry get to see, because these are just notes, not final products. What you see in the final product is a 3-D-rendered marketing illustration, a prop, or CG (computer-generated) scene, but these development sketches normally get shelved. A lot of these various little details and elements in my sketchbook were actually translated into details in *Hawken*.

How did you get into teaching?

I sort of fell into it. In 2008, my friend Kevin Chen, the director of the school Concept Design Academy, was looking for instructors. I hadn't considered teaching, but I'd served as a teacher's assistant in the past. He asked me to give it a shot, and I taught my first class and survived it. I received some positive feedback, and that was enough to pull me back for another quarter and then years.

What are the most common requests from your students?

They often ask to learn to paint, they request Photoshop shortcuts, and they want to learn 3-D. However, I noticed that students sometimes want to skip the foundation drawing. More recently I have switched my class structure to one that focuses more on traditional work as opposed to strictly digital work.

What's your best piece of advice for people who want to work in your field?

To work in the industry, you've got to learn to work well with people. That's something I learned when I started working. At school there was a bigger emphasis on self-improvement (which is just as important), however, I felt I wasn't fully prepared for a studio environment. Most of the time, you don't get to choose the people you work with. So I think being able to kind of push past personality issues, any of those obstacles, will help you out. It definitely helped me a lot. Also, don't beat yourself up over all of the competition that's out there. Don't be afraid of failure, keep pushing forward, and pave your own path!

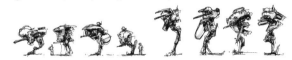

COTTONWOOD ARTS

At Cottonwood Arts we are constantly innovating on how artists interact with the arts. We are honored to have the privilege to develop new products for our creative community. This year we focus on "transitioning artists," designing tools for proliferation and expression.

"for artists by artists"

- Cottonwood Arts Team

8.25 in x 11.5 in 5 in x 8.25 in 5 in x 8.25 in

60 sheets • acid free • neutral PH

Medium weight 180 gsm multi-media brilliant white paper thermal bound for flat presentation and ease of use.

REFILL **REPLACE** **REUSE**

.**Too** Copic is a registered trademark of Too Corporation, Japan. All rights reserved.

copicmarker.com

additional titles from DESIGN STUDIO PRESS

208 pages
Paperback
978-1-933492-73-5
Hardcover
978-1-933492-75-9

96 pages
Hardcover
978-1-624650-70-3

176 pages
Paperback
978-1-624650-45-1

128 pages
Paperback
978-1-624650-10-9

152 pages
Paperback
978-1-624650-27-7

272 pages
Paperback
978-1-933492-96-4
Hardcover
978-1-933492-83-4

96 pages
Hardcover
978-1-624650-69-7

72 pages
Hardcover
978-1-624650-18-5

To order additional copies of this book and to view other books we offer, visit:
www.designstudiopress.com

For volume purchases and resale inquiries, email:
info@designstudiopress.com

To be notified of new releases, special discounts and events, please sign up for the mailing list on our website. Follow us on social media:

facebook.com/designstudiopress

instagram.com/designstudiopress

twitter.com/DStudioPress